LOUISVILLE BEER

DERBY CITY HISTORY ON DRAFT

KEVIN GIBSON

AMERICAN PALATE

Published by American Palate
A Division of The History Press
Charleston, SC 29403
www.historypress.net

First published 2014

Manufactured in the United States

ISBN 978.1.62619.462.5

Library of Congress Cataloging-in-Publication Data

Gibson, Kevin, 1966-
Louisville beer : Derby City history on draft / Kevin Gibson.
pages cm
Includes bibliographical references.
ISBN 978-1-62619-462-5 (paperback)
1. Beer--Kentucky--Louisville--History. I. Title.
TP528.K4G53 2014
338.4'7663420976944--dc23
2014028462

CONTENTS

PREFACE

For an eleven-year-old boy, being offered your first beer—and I'm talking about my very own, not just a sip of Dad's—was quite a thrill. An honor. A rite of passage, even. But I'd just finished mowing both the front and back lawns, it was a hot summer day and I had soaked through my thin T-shirt, so I had earned it, by god.

My memory of the moment is blurry, but when I reached into the fridge for some water, I believe I mumbled something about how good those beers looked sitting there. My father never drank much, but he always had beer in the fridge. Always. It was as much a staple as milk or eggs, even though he might drink only one or two per month.

On this day, I eyeballed a six-pack of Miller High Life "minis" (as my dad called them) on the lowest shelf in our old, white fridge—seven-ounce bottles of the self-proclaimed "champagne of beers" beckoned to me as I stood there, sweat dripping down my forehead from my tangled brown hair.

"You want one?"

"What, a whole one?" I was caught off guard; I'd never been offered a whole beer before—not a beer just for myself. It was always a begged (or stolen) drink or two of my dad's beer on the occasions when he would pop one open. It was like forbidden nectar, and I remember him giving me tastes as early as maybe age six or seven, poured sometimes into the little brown plastic tumbler we had in the cupboard. It would be a small pour—maybe an ounce, if that much—but I felt like a grown-up as I sat on the couch watching football or basketball with my dad, sipping beer as we cheered on the Kentucky Wildcats.

But a whole beer, just for me? Count me in, Dad. And with that, he confirmed the offer, and the deal was sealed. There were no twist-off caps in those days, but I was skilled at opening bottles of Pepsi, so it would be no issue for me to crack open my own beer. My first beer, ever.

While I can't remember what I was wearing that day (probably a UK shirt and tight gray gym shorts, if 1970s family photos are to be believed), I can absolutely remember that first drink of my very own bottle of beer. It was so, so cold, and to this day, I can still conjure a glimpse of that moment by drinking a Miller beer following yard work. Sure, these days my tastes have changed to prefer higher-quality beer, but I won't turn my nose up at a High Life.

And as I drank that first beer, the stuff that had seemed so harsh just a few years earlier seemed smooth, natural. I took a long, measured drink, and the coolness of it filled my senses and soothed me almost immediately. Sure, a glass of Kool-Aid could have done just as good a job at that part, but this was beer. *Beer.*

If you're reading this book, chances are you have a similar story—an awakening, a moment in time that is forever burned into your mind's eye…or your mind's taste buds. That is the moment when you realized the wondrous, glorious beauty of beer.

My friend Jennifer Rubenstein, who works for Keep Louisville Weird, told me during an interview about the Louisville Craft Beer Festival in 2013 that the motto around her office is "Beer is a magical thing." I was talking to her on a bad cellphone connection, and I misheard it as "Beer is a natural thing." But when she corrected me later, we jointly agreed that both assertions ring true. It just feels natural to drink beer. Because of my experience with it—it was always around, even at my grandparents' houses—it simply just *is.* While society has come to take a sour view of the sweetest of beverages, probably due to the focus on drunk-driving deaths, beer is simply one of those things that has always just been there for us.

Beer is also made from natural ingredients—barley, hops, wheat and so on—which is another reason why the word *natural* is an apt compliment for beer. But when Jennifer told me that the word she used was *magical,* I took a step back and realized just how much more appropriate that word is. Beer *is* magical. It was magical that summer day back in 1977 when I heard that *pop* sound of my first beer being opened, and it's magical now. It's magical for all the many flavors and colors and textures in which it exists. It's magical for all the places from which it comes. And it is magical in the way that beer, like almost nothing else in the world, can bring us together and nourish us.

I see beer snobs come and go, with their condescension and negativity, and think about my non-snobby friend Tisha Gainey, founder of the Tailspin Ale Fest, who once told me, "At the end of the day, it's just beer."

Not that she was discounting beer's magical-ness (is that a word?); rather, I took that as her way of saying that beer is not something that should ever cause discord. And that is so *because* it is so magical and *because* it is and should be something that brings us all together. Tisha gets it. As a beverage director for a small Louisville restaurant chain and lover of all things beer herself, she gets it perhaps more than most.

As I grew into my teenage years, I didn't drunk much, unlike many of my friends. I remember the parties I attended where, if enough people pitched in, Miller Lite was the beer of choice. If not, it usually ended up being Busch Light or perhaps one of the versions of Keystone (I seem to recall my young taste buds preferring Keystone Dry if it came to that).

But sometime around 1987, while I was working at a place called Toohey's Auto Supply ("If your car goes blewy, don't say 'phooey'—call Toohey's!"), a friend of my boss who worked for a beer distributor began bringing poor-selling brews into the store and leaving them with us. My boss preferred whiskey, so I usually ended up taking home most of that beer. One I remember in particular was called Lemon and Lager, and it was just what you'd think: a cheap lager-style beer infused with fake lemon flavor—kind of a forefather to that Bud Light Lime stuff that I refuse to try. The first two green bottles of Lemon and Lager I drank were exotic and wonderful. My dad thought so, too. But I think we made it through only half of that case before we started pawning them off on others.

Still, my curiosity was ignited. There was more available than just corporate light beer? I had no idea that there *was* anything else. One beer that distributor dropped off was an amber ale. An amber ale? Are you kidding me? "This stuff is the wrong color. It's not even yellow!" I believe it may have been a Berghoff beer, and it was much better than the Lemon and Lager. That case didn't last long.

But it wasn't until 1992 that something big started to happen for me and my beer curiosity. That's when Silo Microbrewery, the first brewery in Louisville since Falls City closed its doors in 1978, opened on Barret Avenue near downtown. I remember going there for the first time and ordering the first wheat beer I'd ever had. Of course, it was unfiltered and, if I recall correctly, was served with a lemon wedge.

My then-wife took one look at the cloudy, yellow brew and said, "Why does it look like that?" I had no idea. Beer isn't supposed to be cloudy, is it?

My intrigue was heightened. What I didn't know was that just across the river in New Albany, Indiana, a little place called Rich O's Public House had already begun bringing craft beers on draft to the Louisville area. Then, in 1993, Bluegrass Brewing Company opened its doors. At that point, the local beer movement in Louisville was on.

But it was bigger than that, as I would learn through my growing interest. I had not realized until that point just how big brewing was in Louisville prior to Prohibition and even for many years after. This book will turn back the clock to the early years of Louisville brewing, taking a look at the early German settlers and following the beer industry through Prohibition into the downfall of Louisville brewing and, finally, its resurgence. As you will see in this book, Louisville went from almost nothing to being very much a beer city in a bourbon state; it stood as one of the top ten brewing cities in America at one point. So successful was Louisville's brewing industry that it sparked an industrial uprising that included labor disputes, rivalries, monopolies and takeovers.

The joy of beer, however, was never lost on those who enjoyed it in the many beer gardens and saloons around town. I studied newspaper accounts, memoirs and legal documents and devoured the fantastic book *Louisville Breweries: A History of the Brewing Industry in Louisville, Kentucky, New Albany and Jeffersonville, Indiana* by Conrad Selle and Peter Guetig in coming up with a picture of what life might have been like for beer-loving Louisvillians over the past century and a half.

And I confess that in researching and writing this book, I myself enjoyed a beer or two (or one hundred; I lost count around the thirteenth chapter), which is sort of the point of the whole thing. Many days I sat down at my favorite local watering hole, sipping a choice brew while writing, and I spent many afternoons interviewing local brewers, historians or citizens who had memories of the way it used to be, with a beer within my mouse hand's reach. (I won't say that I was ever inebriated along the way, but I will say thank goodness for editors.)

My hope is that you, the reader, will come away with a better understanding of what beer has meant to Louisville over these last 170 or so years. I will tell you a bit about what it was like to work at one of the city's many breweries. I will reveal the joy and the (sometimes) bitter heartbreak. I'll tell you about the beer barons, the major breweries and how the temperance movement and Prohibition helped destroy so much of what had been built, and then I'll take you on the ascending journey to today's brewing boom in Louisville. Yes, bourbon is king today, but beer had its due. One wonders

what Louisville might have meant to brewing if Prohibition hadn't wiped out all but a handful of breweries.

And yet, it is nevertheless an exciting time right now in the city, and I'm thrilled and honored to be able to follow it so closely as a writer and to have access to the people who have helped make it happen and who will carry it forward. I'll introduce you to some of the brewers and visionaries who helped bring Louisville brewing back from extinction and reveal some of the personalities that make the current beer scene so exciting and enjoyable.

So sit back, prop up your feet and crack open a bottle, can or growler of your favorite brew. The delicious and intoxicating ride is about to begin.

ACKNOWLEDGEMENTS

Where to begin? Good grief, I have no idea. Perhaps I will start at the beginning. First, it was my good friend Fred Minnick (whose name you know if you love bourbon), who introduced me to my patient and understanding commissioning editor at The History Press, a lovely lady named Kirsten Schofield. How that woman deals with writers all day, I'll never know, but much love to her for her patience and understanding.

Lisa Pisterman (a Louisville historian whose name you know if you live in Germantown and Schnitzelburg) was also of great help as I got started on my research. She hooked me up with George Hauck and Don Haag, who chimed in with some fun stories that add a lot to the book. I want to thank the Louisville Free Public Library for having so much great history online. I also owe a debt of gratitude to Sarah Kelley, my boss, for being so patient with my schedule as I was working to get this book finished.

And the beautiful photography you see in this book was no accident either. The amazing Rick Evans went above and beyond the call of friendship in his contributions, as did the lovely Cassie Bays. And my pal Chuck Johnson introduced me to Jeff Mackey, whose outstanding photography work you also see in these pages. I must say that those photo shoots were fun days—anytime you're taking pictures in a brewery, it really can't possibly feel like work.

Extra-special thanks go to David Pierce, Roger Baylor and Pat Hagan for being so accommodating. Heck, all the breweries around town were great. Leah Dienes at Apocalypse Brew Works is the best friend a writer (and beer lover) could have, and the same is true for her cohorts Jane and Bill Krauth.

The guys at Great Flood Brewing—Matt Fuller, Zach Barnes and Vince Cain—are consistently awesome. Rob Haynes over at Falls City Beer hooked me up big time on a few occasions, Scott Lykins and all the folks at BBC Tap Room were fantastic and thanks also go to Dave Easterling for letting me photograph the collection in his Falls City taproom. Everyone at New Albanian Brewing was awesome (hi, Ben and Peter!), as were the guys at Cumberland Brewery and Against the Grain Brewery and Smokehouse, as well as the uber-friendly Paul Young at My Old Kentucky Homebrew. Thanks to Conrad Selle and Peter Guetig for writing their incredible 1995 book about Louisville's brewing history; it was a godsend. Thanks also to David Timmer and Marvin Gardner. And thanks to John King, the king of Kentucky beers. Thanks to Kenneth Schwartz, a wonderful man who gave me lots of insight into what brewery life was like. And thanks to the bartenders at Buffalo Wild Wings. I also want to thank the late Alma Kellner, whose heartbreaking story became something of an obsession during this journey.

Mostly, I should thank all my friends and family for their never-ending support and encouragement. Without those people in my life, I wouldn't have a life. Cynthia Bard was simply amazing throughout the entire process. My parents, Ron and Jula Gibson, offered wonderful support and didn't flinch or even roll their eyes when I sat on their back deck prattling on about beer history. My dog, Darby, may be the best snuggler ever, which was nice after long days and nights of researching and writing. (I recently read a spot-on Lawrence Kasdan quote: "Being a writer is like having homework every night for the rest of your life." It is so, so true.) Finally, I also want to thank anyone I missed—my brain is a little scattered as I reach the end of this project.

But I think most of all, I want to thank myself. Why? Because I worked my butt off, that's why. I sure hope it shows. The crazy thing is that I can't wait to do it again.

THE IMPORTANCE OF BEER

There was beer on Noah's ark. OK, that can't really be proven, but some historians theorize that Noah was less the great man of piety and more a beer trader who sold his fermented alcoholic beverages at stops all along the Euphrates River—a beer barge of sorts, captained by a man just trying to make a living. The traditional biblical story of Noah saving his family and hundreds of species of animals, some historians say, stems from an earlier tale in Sumer.

It's debatable, but what isn't up for debate is the importance of beer throughout human history. Heck, it was the first alcoholic beverage ever created. Some historians theorize that beer came about when humankind ceased to be nomadic and began to farm. You grow grains, and what do you make? No, not bread—*beer*. You have to preserve those crops somehow. And yes, beer was even made with these grains before bread, proving that our ancestors had their priorities neatly in a row.

One of the magical things about beer is that it can be made from so many different ingredients, and that leads to an intoxicating variety of options for those who brew. It also has traditionally made beer identifiable by culture and region. Ancient African brewers used millet, maize and cassava to make their beer. The Chinese would use wheat, while Japanese brewers used rice. Egyptians used barley. History shows that hops, the primary ingredient in modern beer, weren't used until about 1000 BC, a full two thousand years after historical records place the first evidence of beer being brewed by the Sumerians in ancient Mesopotamia. However, it is worth noting that beer is likely much older.

Archaeologists have actually discovered ceramic vessels from 3400 BC that were still sticky with beer residue, and a song of praise for Ninkasi, the Sumerian goddess of beer, goes back much further. The song even includes a recipe of sorts that mentions honey and wine, as well as malt and grains, and describes the cooling of wort and ultimately pouring filtered beer from the "collector vat." Apparently, Tom T. Hall, who made "I Like Beer" a hit back in 1975, wasn't the first to celebrate this most wonderful of liquids in song.

But beer became commonplace quickly, particularly in Egypt, where workers were often paid with an allotment of a sweet brew. Everyone, regardless of class, drank beer as part of their daily diet—even children. In Babylon, for a full month after a wedding, the bride's father would supply his new son-in-law with all the mead or beer he could drink. Sort of a bachelor party in reverse. But it is significant that the month after a wedding was referred to as the "honey month," which eventually led to the term "honeymoon." (It is widely believed that, even today, many men and women drink beer on their honeymoons. Ahem.)

As centuries passed, Christian monks in the Middle Ages began using hops to season beers. Once Europeans began immigrating to the New World, it was only natural that beer would come along for the ride. In fact, it is part of legend—and may actually be true—that the *Mayflower* finally chose its landing spot in New England because it had run out of beer.

One of the key reasons for beer's popularity all those thousands of years ago, quite frankly, was because water usually wasn't fit to drink. Sure, it's not a romantic notion, but it's the truth. Contaminated water could make you very sick or even kill you. But a delicious beer was free from that risk, and heck, it even made you feel good. We know now that the boiling step in brewing kills the germs that would poison us, but at that point, English settlers had not yet made the connection; they did not know to simply boil their water. Or maybe they did know and just preferred to drink beer.

Beer is not without social significance either, just as it has been down through the ages. Quite simply, it is a drink for everyone, and one for everyday enjoyment. It's hard to beat that notion. Think about it: If you break out a bottle of champagne, someone will wonder aloud what the celebration is for. Wine is thought of as a meal companion and cognac or brandy as after-dinner treats. Bourbon, a Kentucky staple, has long been thought to be a gentleman's drink—one now enjoyed by women as well.

But beer? Beer is for when you want to just relax, socialize and enjoy yourself. Enter the British and Irish pubs and the German beer gardens. The latter would become staples in Louisville as settlers began to emigrate here

in the early to mid-nineteenth century from Germany, Ireland and other countries. These people worked hard, and for Germans in particular, beer was their reward. However, it was perhaps less about the beer and more about time spent with friends and family at the end of a difficult week. Life for an immigrant family was not easy; Louisville was but one city that provided a home where these people could build lives similar to the ones they knew in their homeland, and build them they did, from churches to shops to gardens to breweries.

When they ate or celebrated, these Louisvillians would make sure that beer was present. It was a way of life, and it became a way of life for Louisville, even though Kentucky was then and is still far better known for its bourbon whiskey. It is estimated that by the late 1800s, dozens of breweries of varying sizes were operating in Louisville, and a newspaper account in 1902 reported that in the previous year, so much beer had been produced and sold that each Louisville resident could have had one barrel of beer by him or herself. By contrast, as of this writing, there are fewer than ten breweries in Louisville, and none produces more than a few thousand barrels per year.

But as much as Louisville's brewing industry was on the rise, beginning with the first commercial brewery on record in 1808—owned by a man named Elisha Applegate—it is on the rise again today. Prohibition nearly killed brewing in Louisville, and it left its mark for many decades before Louisville's breweries were finally killed by corporate brewing empires from St. Louis and Milwaukee. But the new wave of Louisville brewers comes armed with passion and creativity, and it caters to a diverse crowd of beer enthusiasts who have come to appreciate beer much as their nineteenth-century forebears did—perhaps even more.

But let's not get ahead of ourselves. It's a long tale to tell.

THE GERMAN INFLUX

Most beer made in Louisville prior to the early 1800s was made at home, which explains why there are few, if any, records of commercial breweries. Well, that and a lack of official recordkeeping. In fact, most colonial homes were built to include small brewing rooms, often identified as a semi-independent part of the house that jutted out from one side of the structure.

While it seems strange today, in early colonial days, everyone drank beer—men, women and children—and they drank it often. In fact, many would begin the day with a pre-breakfast ale, and beer would be served with every meal into the evening. Beer is what got many through a long, difficult day of labor. In other words, beer was not thought of as a recreational beverage, as it is today; it was a staple of life that was especially recommended for breastfeeding mothers for its nourishing qualities.

The first settlement in Louisville in 1778 was surely no different, so despite a lack of records, we can assume that beer was a staple in Louisville almost from the time George Rogers Clark set his first booted toe in Kentucky and southern Indiana.

By 1829, according to Guetig and Selle, immigrant brewers began arriving in Louisville, and this is when commercial brewing began to take shape in earnest. It is around this time that recordkeeping became more organized in Louisville, and it was not long after this that German immigrants began to discover that Louisville was a perfect place for them to settle and make new lives for themselves.

Following the European Revolutions of 1848, a huge influx of German-speaking settlers came to Louisville, and by the mid-1850s, there were roughly eighteen thousand Germans here, making up more than one-third of the city's population. They built homes, opened bakeries and butchering operations and congregated in an area of town now known as Germantown and Schnitzelburg. With the arrival of these German settlers came the brewing boom, an explosion whose aftershocks would resonate for about seventy-five years.

German immigrants were meticulous about leaving their homeland; they didn't just jump on a boat and land wherever they could. They would contact a local priest and ask him to help find a place for the family to settle in America. This priest would, in turn, contact an established German Catholic church in America, which would then contact another. Louisville quickly became a choice destination.

"When they got here, there were people waiting who spoke their language, went to the same church," said Lisa Pisterman, a Louisville historian who authored the book *Louisville's Germantown and Schnitzelburg.* "It was methodically thought out and well planned, and people were safe."

Despite the presence of beer in Louisville's culture, however, the existing population—particularly Protestants—did not consume beer as voraciously or as openly as these incoming Germans, who quickly built lavish beer gardens in which they would imbibe, dance and sing. And then they would imbibe some more.

Saloon/grocery store hybrids sprang up all over the Germantown-Schnitzelburg area; imagine an old-time corner store, with bread and sundries, as well as two swinging doors in the back that led to a small saloon where beer flowed freely. In one photo from the era, an awning on one such grocery/saloon reads, "Der Pfalzer Heimath," which Pisterman said translates roughly to "beer of the homeland." This was life in Louisville starting in the mid-1800s and carrying into the early twentieth century.

"[Beer] was just another thing they made," Pisterman said. "It was like baking to them." Unfortunately, many of the German settlers who came to Louisville following the Revolution of 1848, known as "Forty-Eighters," were not well received. These were outspoken people with political ideals that did not mesh well with those of the existing population. It is perhaps ironic that these settlers' love of beer is what helped fuel the steady rise of temperance sentiment in Louisville and caused many to look negatively on the German beer gardens and saloons that became such a big part of Louisville's 1800s landscape.

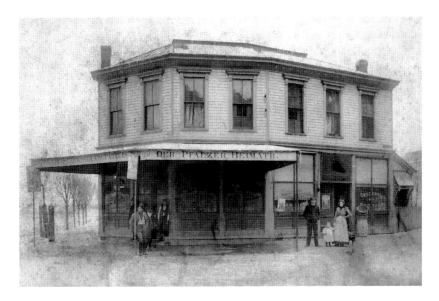

A Germantown grocery and saloon for Hartstein headquarters. In the photo (at right) are Christian Hartstern, who went by "Christ" (pronounced "krist"); his wife, Bertha; and their only daughter, Christine. The other people are not identified. Historian Lisa Pisterman said that the words "Der Pfalzer Heimath" on the awning translates roughly to "beer of the homeland." *Courtesy of Tammy Ruff Scrogham.*

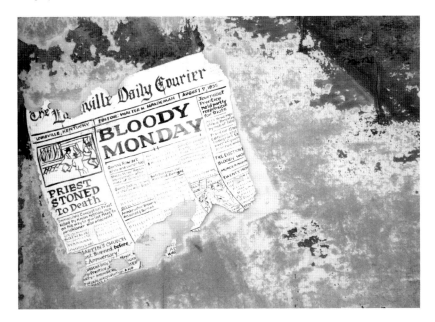

A mural on the last remaining building of the Phoenix Brewery commemorates the Bloody Monday Riots of 1855. *Cassie Bays photo.*

As I noted earlier, beer should be enjoyed, and it should be something that brings us together. These Germans understood this, but not all in Louisville did. Essentially, many of Louisville's existing citizens were heavily against immigration (yes, it was a polarizing issue even then), with many of those so inclined largely making up a political party that became known as the Know-Nothing Party. These Know-Nothings felt that the "foreigners" were defiling the Sabbath day because they engaged in their merrymaking most often on Sunday. The reason for this, however, was because these were hardworking people who spent the other six days of the week running their businesses, building and maintaining their homes, earning a living and taking care of their families.

"I think for a long time, your day was: you got up, you worked, you went to church, you came home," Pisterman said. "There was an endlessly long day. They got up at five in morning. It was hard back then. Work was rough. Even the women, [with] all the stuff they had to do by hand at home—it wears me out to think about it. At the end of it, after dinner, what was better than go have a beer, talk about the homeland, and talk politics?"

Therefore, Sunday was the day to unwind, take a breath and get ready to do it all again. This didn't sit well with the Know-Nothings, and the resulting unrest led to the Bloody Monday Riots on Election Day, August 6, 1855, in which a number of German businesses were burned and otherwise attacked; many German settlers were assaulted or even killed. Irish settlers were targeted as well. Quinn's Row, a block of houses and apartments (ten or eleven structures) occupied by Irish immigrants, was completely destroyed. The attacks went on for days, with more than one hundred homes and businesses being damaged or destroyed, and many immigrants fled the city.

Armbruster's Brewery was badly damaged in the fray, sustaining $6,000 in damage, while an adjacent brewery, Green Street Brewery, owned by a man named Adolph Peter, was also attacked. Three attempts by rioters to burn Green Street Brewery failed, however, and it was spared significant damage. In the attack on Armbruster's, according to an account in the *Louisville Daily Courier*, a cart driver named Sadler was badly wounded. His wife fled the scene in the pandemonium but "could not gain admission into the houses of any of her friends for fear of their being mobbed."

It was tragic because these "foreigners" had deep religious convictions, and their celebratory Sundays were as much a part of the Sabbath as going to church. "God was so important to them," Pisterman said. "God and beer." And it showed. According to Guetig and Selle, by 1850 there were six breweries in Louisville, all but one owned and operated by German-speaking

immigrants. Within nine years, there were seventeen breweries, sixteen of which were owned and operated by German-speaking immigrants. The lone English brewery, which was producing ales and porters, would be closed by the following year, even though at the time it was Louisville's oldest brewery, having opened in 1832. (We'll learn more about many of these brewers later in the book.)

Similarly, by this time, fifty-three saloons were listed in the city directory of 1858, and more than 90 percent of those were German-owned and likely situated in and around Germantown and Schnitzelburg, as well as in nearby downtown and Butchertown. And they were patronized by German settlers as well. "If nine-tenths of the breweries were owned by Germans," Guetig and Selle wrote, "they probably consumed about that proportion of the beer produced."

God bless those hardworking German immigrants for bringing their wonderful lagers and bocks to Louisville, as well as for bringing saloons and a general appreciation for beer. Perhaps most importantly, I am grateful to them for bringing the concept of the beer garden from Germany to Louisville. While none of these beer gardens exists today in the city, they are still felt and even imitated to some degree at various spots around town. But nothing we have today compares to the beer gardens of Louisville in the late 1800s and early 1900s. Our next stop in the rise of Louisville beer will be to explore these very sites.

THE BEER GARDENS
OF LOUISVILLE

On October 2, 1861, Colonel August Willich's all-German Thirty-second Regiment Indiana Volunteer Infantry arrived in Louisville from Madison, Indiana. It had traveled on the steamboat *N.W. Thomas*, which carried the nearly nine-hundred-strong regiment that was attempting to increase its numbers with a visit to the immigrant-strong city.

According to *Indiana's German Sons: 32nd Volunteer Infantry*, by Michael A. Peake, the group's initial arrival in Louisville was a tragic one:

> *As the boat was docking, Private Rudolph Kranefus of Company G fell overboard and was swept away in the swirling darkness. His life's adventures as a soldier ended at the beginning of his fourteenth day of service with a juvenile attempt to leap from the* Thomas *to another docked vessel. Search parties, impeded by the seasonal high water, unfortunately failed to recover the body. With the gloom of the accident overshadowing the men, the 32nd turned to the rousing Louisville welcome lavished upon them later in the day.*

That welcome took place at Woodland Garden, a lush beer garden located between Main and Market Streets, just north of Wenzel, south of Johnson and adjacent to the Bourbon Stockyards, where a large plumbing supply company sits today.

"Louisville's large German population was ecstatic over the arrival of Willich's regiment," Peake wrote. "At noon on their first day in the city they

were the guests of honor at a large festive gathering, heavily provisioned with tables of food and kegs of beer, held at the Woodland Garden." The celebrations continued around Louisville in saloons and beer gardens in the ensuing days, and you can bet that plenty of beer became a casualty of the local Germans' excitement.

Woodland Garden was a well-traveled entertainment spot at the time and was the recreation center of choice for most of Butchertown's German-speaking residents. (Butchertown was so nicknamed because of the stockyards and butcher shops located there.) Based on descriptions of the time, it was typical of such gardens of the era, with bowling, singing and general revelry, especially on Sundays, along with plenty of tables and chairs where locals would sit, socialize and sip beer. Trees and lush greenery were staples of these gardens.

An 1875 *Courier-Journal* account describes an annual "Old Bachelors Picnic" outing that included "very few old bachelors and old maids," instead being largely attended by the "younger element of the sexes…Much beer was drunk, much music discoursed, and much dancing was done, and taken altogether it seemed to the looker-on a very laborious, but yet pleasant, night's enjoyment, for dancing through a midsummer's night is tiresome, hot work, although the fatigue is not felt fully until the next day."

The writer noted that the Woodland Garden proprietors could, at the following year's Old Bachelors Picnic, expect a similar scene "and just as careless a disregard for both the leg and stomach capacities."

On June 12, 1871, a festival at Woodland Garden benefited a local German "orphan asylum," with the gates opening at about 8:30 a.m. and a large crowd assembling by 3:00 p.m. "The various refreshment tables, the bowling alley, the dancing halls, etc., presented a lively appearance…Vocal music was given by the children at interval during the afternoon on an elevated stand." Later that night, a brilliant fireworks display capping the evening could be seen "from a great distance."

At a similar festival four years earlier, the open-air garden was described as being filled with "flowers and fountains," and "beer and wine, substantial edibles of every kind, including strawberries and cream, were there in abundance." *Courier-Journal* editor Henry Watterson described the block-long Woodland in the late 1860s as being best remembered for "good music, good beer, good sausage, good cheese and a pretzel."

All of this illustrates that many of these "gardens" were actually full-blown entertainment complexes, and German people flocked to them. Like at home in Germany, or the "Vaterland," they were social centers, and the activity and

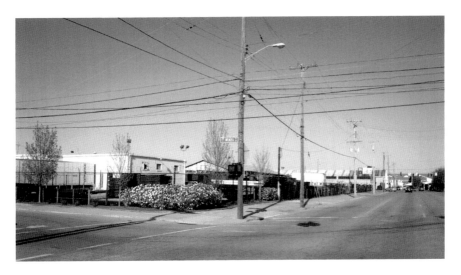

The site in downtown Louisville near Butchertown that was once Woodland Garden. The beer garden took up the entire block between Main and Market Streets. *Cassie Bays photo.*

fellowship revolved around beer, food and general merrymaking. Best of all, the gardens catered to families, not just beer-drinking men of the time. And still, according to *The Encyclopedia of Louisville*, beer gardens sold five times as much beer on Sunday as during the rest of the week combined—so there was no shortage of beer drinking going on during those welcomed off days.

The early Louisville beer gardens of the 1820s and 1830s, including Woodland, were mostly frequented by English-speaking Louisvillians, but by the mid-1850s, that had begun to change. Woodland, originally owned by English locals, was later sold to a German owner (before finally closing in 1880). Thus, the beer gardens became associated with the German settlers.

In August 1875, an essay in the *Courier-Journal* titled "Studies in a Beer Garden" contained this passage:

> *Here is a jolly party, careless, free, happy and filled with thoughts of the Federland; they are your true philosophers over a glass of beer. They extract a hidden meaning from each glass, a dozen of them, to a German, are a poem, sweet and rhythmical as the ripple of the waters of the streams by which they played in happy childhood days. There's no use studying a German at a beer garden. His soul is in his face, his heart is open to you, and a glance tells the story.*

And they were indeed bright, merry places, if descriptions do them justice. An 1883 description of the Lincoln Park beer garden relates a serene holiday evening there: "Through the archways and trees you catch a glimpse of the hundreds seated at small tables over their beer or walking around to the music of the bands, their many-colored dresses making bright pictures against the background of foliage."

There was a beer garden at Fontaine Ferry Park, a popular amusement park, and a news story from April 1900 about the arrival of spring painted this picture: "Strolling mashers, 'tuff guys,' and children with red cheeks and plaid stockings were crowded together at the beer gardens at the front of the park."

Breweries in general were social centers; a gentleman named Joseph Jacob Eisenbeis, who was born in Louisville in 1890, wrote a memoir describing life in Louisville during his youth. Eisenbeis lived on Logan Street, not far from the Schaefer-Meyer Brewery, which he said made the best beer in the city. He wrote about a parade and picnic that occurred in the late 1890s in the lot adjacent to Schaefer-Meyer:

> All Swabs, mostly immigrants and their families and descendants, would gather here in early summer every year for this Schones Schwabenland Fest...The parade started. Wagons and horses were furnished by brewerys [sic] in this section of the city, all decorated with flashing colors, the people were all dressed in their wearings as they were in Germany. It was a beautiful sight to see such enthusiasm.

According to Eisenbeis's memoir (which, fair warning, contains a number of grammatical errors), such beer gardens, often just called "parks," were everywhere. Further, he wrote, "Very likely the Mose Green Club had the largest picnic or gathering for dancing and a very good time was had by all. It was a very lively celebration of what a hot time would be. The people came for their [c]elebration from all over the city and from the red hot district of 10th and Green."

This passage perhaps best describes the large number of parks, as well as what they meant to Louisville at the time:

> There were other parks in Lou[isville] at that time but not like [Phoenix Hill]. Summers Park, [right] side of 3rd St. near Iroquois Park mostly for church picnics. Sennings Park had restaurant service and dancing and a very good musical band across from Summers and nearly was the beginning

of the Louisville Zoo, but the…Zoo could not make it profitable, because no one seemed to know how to operate it so it faded away. Schneiders Park also was in the same neighborhood of Iroquois Park with the same services as Sennings. Served by 3rd and 4th St. [street] cars. Lion Garden Park, later Woodland Garden…Another was Eisenmeyer's Park at 41st and Market Sts. All of these parks were family beer garden parks.

To put an exclamation point on his memories, he finished the passage with this: "In those days people were very happy, as there were no wars nor rumors of war, the world was at peace, nothing much to worry about. Very likely that's why they named it the gay ninetys."

Beer garden waiters and bartenders also had quite a reputation for being colorful characters. In a *Courier-Journal* piece in April 1888, these waiters were described as being "invariably white" and usually of German descent, often wearing an apron, with towels laid over their forearms. "He is," the piece reads, "as a rule, independent, pugnacious and inclined to take his own tip by making a 'mistake' in making change. This mistake was never known to be against himself."

And if you didn't speak up quickly, he would walk away, and your money was gone for good. These waiters generally would work two or three days or nights a week during summer months and maybe just a shift or two per week in winter, when business slowed. Working on sales percentages, tips and "mistakes," they were described as able to "make as much in that [week], generally, as the colored house boy can make by two weeks steady labor."

Another popular beer garden, Zehnder Garden, stood at the intersection of Bardstown Road and Baxter Avenue in the Highlands (at the current location of a Kentucky Fried Chicken fast-food restaurant).

In 1889, it was described as "a cool and inviting retreat," and it was the home of Zehnder's Cherokee Park Tavern, a three-story structure that no doubt was the site of much imbibing and dancing. In a photo dated to about 1890, the tavern is surrounded by full, lush trees, with benches in front of the place in a small park area, along with what appears to be a gazebo. Outside stand three horse-drawn carriages, as three stern-looking men in white shirts and dark vests (one appears to be wearing an apron and is probably a barkeep) stand looking idly toward the camera. Four steps lead to a large front porch over which an awning hangs, with lanterns affixed.

The Zehnder beer garden, which was also known as the "Sign of the Buck," also had a pond on the property that was used to chill beverages, according to a history compiled by the Cherokee Triangle Association. What

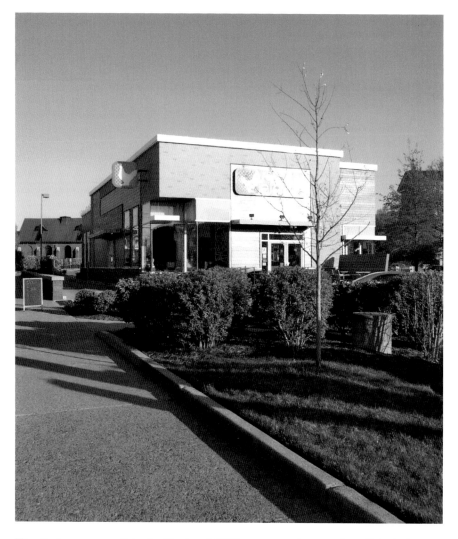

The site that was once Zehnder Garden. A KFC restaurant sits near where Zehnder's Cherokee Park Tavern once stood. In the background is the Holy Grale, a church that has been converted into a craft beer gastropub. *Cassie Bays photo.*

a spectacle that must have been—dozens of kegs of beer bobbing in a pond, waiting to be consumed. Sadly, by the early 1900s, Zehnder had closed, and a short piece in the *Courier-Journal* on April 21, 1903, said that the place had been auctioned off piece by piece and lot by lot.

Of course, life in beer gardens wasn't always rosy. A headline in the *Courier-Journal* from September 14, 1897, was "Brawl at a Picnic," and the article

related the story of Henry Fetter, "quite a well-known bowler," who won a bunch of checks (beer credits) at Zehnder and invited some men to drink with him in celebration. One man, however, Phil Hartman, took offense at something Fetter did and "struck Fetter three times with a brick." Fetter drew his gun and shot at Hartman but missed, leading to Fetter's arrest. Hartman escaped. Maybe the beer was just stronger at Zehnder than at the other beer gardens.

But the crown jewel of beer gardens in Louisville was Phoenix Hill Park, part of the Phoenix Brewery complex, which opened in 1865. Forget Disneyworld—based on descriptions, this must have been the happiest place on earth, at least in its day.

In addition to being home to a large brewing operation, the park was built on a huge hill described as being four stories high, and it was designed by co-founder Gottfried Miller. In that hill were dug four giant beer cellars to hold the aging lager beers made by the brewers. The park itself was enormous, featuring, as described by Guetig and Selle, not just a beer garden but also a grove that measured up to three acres, a dance hall, an outdoor bandstand that saw untold numbers of concerts performed there, a bowling alley, a skating rink and a bar that measured 111 feet long. There also was an extension of a summer garden that jutted out from the hill and was supported by timbers, providing a sort of city overlook, probably facing north across Baxter Avenue. (On April 27, 1884, this platform collapsed, injuring several men and women, who fell from the hill in the collapse, though none seriously.)

In addition to concerts and other shows, the park was also host to many political rallies. Theodore Roosevelt headlined a rally there on April 3, 1912. Chances are that he did not greatly enjoy the beer he was served that day, as he would be quoted at one point by a newspaper in Milwaukee as saying, "Nothing of merit was ever written under the inspiration of lager beer." Whether he intended to slam beer in general or just the style can be left up to your discretion.

Phoenix Hill Park would open each year in May and would be the summer-long social center of the area, with euchre tournaments, ragtime acts and vaudeville shows. For sports, there was also boxing and polo. An indoor baseball game was played there in the dance hall in 1891, and in 1897, six-day bicycle races were held in the "bicycle bowl." There was also an appearance by the Rough Riders, a group inspired by Teddy Roosevelt's band of soldiers, including one who was costumed to look like Roosevelt himself. In 1906, a newspaper account reveals, Phoenix Hill Park played host to a pig-chasing contest. You can't make this stuff up.

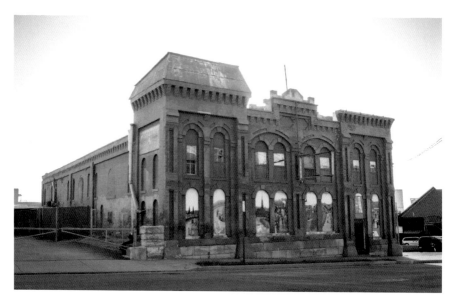

The last standing building from Phoenix Brewery now houses Acme Auto Electric. It is decorated with murals commemorating the brewery and beer garden. *Cassie Bays photo.*

Descriptions of the time echo the activity and beauty of the park. A passage following a German concert in 1881 reads, "Anyone who has groped among the dark beer dungeons which lie for a number of deep streets under Phoenix Hill, would scarcely imagine while in those dark, chilly caves, that far above him the place should grow into such an efflorescence of beauty, fashion and brightness."

A photo of a German picnic at Phoenix Hill dated August 1912 shows German gentlemen seated around small rectangular wooden tables on frail-looking wooden chairs. Mugs of dark beer sit within close reach. There are suits and bow ties all around and fedoras on their laps. In the background can be seen women in dresses and wide-brimmed, ornate hats, standing in a group.

A 1916 Labor Day festival at Phoenix Hill Park drew some ten thousand people, according to the *Courier-Journal*'s account the next day. The day began with a parade witnessed by fifty thousand onlookers, and from that point on, it was pure "merrymaking," which included an address by former lieutenant governor E.J. McDermott as people "sat under the trees, sipped cooling drinks and consumed frankfurter sandwiches."

Further, the account noted, "as the pleasant evening wore on, numerous 'good fellow' singing parties formed at the more happy-hearted tables."

A photo from the *Courier-Journal*, circa 1912, depicting German settlers enjoying a day at Phoenix Hill. *From the* Courier-Journal *archives, Louisville Free Public Library.*

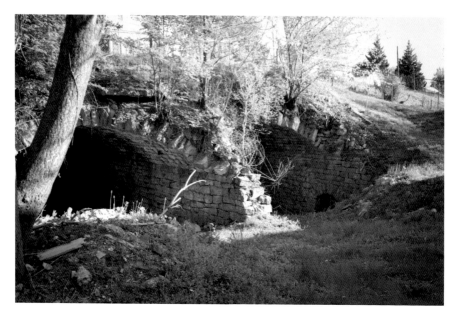

The beer cellars beneath Phoenix Brewery are still visible, not far behind the former horse stable on Baxter Avenue. *Cassie Bays photo.*

There is a fair chance that "happy-hearted," in this context, could be equated to "heavily inebriated."

Our friend Mr. Eisenbein wrote in his memoir:

> *Phoenix Hill Park was an ideal place for a picnic or any family gathering. I'll say the most popular park in Lou[isville] at that time. Phoenix Hill at the apex of its glory. The lights from this gay and glorified beer garden could be seen and the music heard over a good part of the east end, because of the high location overlooking downtown Louisville. There was a floor for dancing, bowling alley and later a roller skating rink, a music pavilion where bands would amuse the crowds. I myself played the clarinet in Jacob's Brass Band at St. Joseph's Catholic Church Picnic in this bandstand.*

Unfortunately, when Prohibition killed Phoenix Brewery in 1919, the park went with it. It reportedly fell into bad disrepair, and by 1938, it had been torn down. The hill was leveled with it, and the ruination of the park is a fitting metaphor of its time, symbolic of the fate that befell Louisville's brewing heyday. One building, which once served as the horse stable, still

stands and is now home to Acme Auto Electric. The gray Victorian building is decorated with murals commemorating Phoenix Park. Not far behind it sit the long-abandoned beer cellars.

Of course, during Louisville's brewing heyday, the city was also well populated by taverns, which were the smaller, indoor, less family-friendly answer to beer gardens. Yes, those saloons and taverns were whiskey centers, but beer became more and more of a staple as Louisville's brewing industry grew. Next, let's take a tour through Louisville's taverns and saloons.

THE SALOONS OF LOUISVILLE

S aloons and taverns have a far longer history in Louisville than brewing. Plenty of travelers passed by and through Louisville via the Ohio River when America was being settled, and by the 1770s, an establishment called Harrod's Tavern was operating at River Road and Guthrie Beach, according to *The Encyclopedia of Louisville*.

In those days, a tavern was as much a hotel as a place to drink (mostly hard cider, at that point), providing shelter and a place to rest for weary travelers heading west, even though typically they were just one-room shacks or cabins. But taverns and saloons evolved with the city and the people living here through the years, and they continue to serve beer and food to Louisvillians today.

By the end of the 1700s, with the rise of stagecoach travel, more and more taverns had sprung up in Kentucky along routes that settlers preferred. In time, they became not just pit stops for travelers but also local gathering places where men could get news from those passing through as well as from the bartenders and other customers.

Daniel Gilman set up such a tavern at what is now the intersection of Shelbyville Road, Westport Road and Breckenridge Lane (interestingly, there is not just a brewery near that location now but also a number of places where one can get a cold beer, such as Gerstle's Tavern). Soon, taverns such as this one became indoor beer gardens of sorts, the difference being that in those days, the preferred tavern drink was whiskey.

As travel west increased by the early 1800s, more and more (and larger) taverns and hotels sprang up. Hotels often had a tavern attached, no doubt

serving as forefather of today's hotel bar. These taverns grew as gathering places, with entertainment like music, freak shows and fortunetelling. There were plenty of these taverns and saloons to go around. *The Encyclopedia of Louisville* names many: the Indian Queen at Fifth and Main; Washington Hall at Main and Third (where a Bluegrass Brewing Company location now sits); a Louisville Hotel tavern at its Main Street location between Sixth and Seventh Streets; and the Galt House, which originated at Main and Second. A modern version of the Galt House, a two-hotel complex complete with bar, is now located at Fourth Street between Main Street and River Road. Other downtown taverns in the early 1800s included the Wall Street House, the Kentucky Inn and the Kentucky Hotel.

As time went on, the hotel taverns were filled more with travelers, while the stand-alone saloons catered primarily to locals. Not unlike in Europe, saloons began popping up in every neighborhood as gathering places for the exchange of news and company, as well as being good places to have a drink and some food.

It is no surprise that these saloons, which were often dank, narrow places, followed the rise in beer's popularity and brewing in Louisville from the mid-1800s until Prohibition. A story in the *Courier-Journal* from 1868 describes these saloons: "It is a little remarkable, but true, that there is not a saloon in this city fitted up in first-class style. The amount of patronage bestowed upon them would justify the proprietors in fitting up handsomely, and renting large and well-ventilated rooms in which to serve their customers. As they are now, it is almost impossible to get out when you get in, or in when you are out, on account of the narrow and contracted space they have." Can you imagine the smoky, loud nature of these saloons? There was no smoking ban in Louisville in those days.

This aforementioned *Courier-Journal* article describes a number of the city's more popular saloons of the day, with information on beer sales: the Empire Saloon on Fourth between Main and Market was operated by Otto Brohm and sold about fifty kegs of beer per week. Meanwhile, Phillip Breckheimer, whose saloon was situated on the west side of Third Street between Market and Jefferson, "jerked" about sixty-five kegs per week. The Headquarters Saloon on Green (now Liberty) between Third and Fourth sold about thirty kegs per week in those days, while the Eldorado at the northwest corner of Jefferson Street at Third went through about forty kegs per week. Beck's Hall, on the north side of Jefferson between First and Second Streets, had an adjoining beer garden called Heuser's Garden, and between the two of them, they went through about thirty and thirty-five kegs per week.

This article noted that much of the beer sold in Louisville at the time came from Cincinnati, Madison and Milwaukee and that a fair portion of the beer brewed by the twelve or so breweries in Louisville went out of town to cities south of Louisville. Of course, this was just the beginning of brewing in Louisville—if the article is correct that the city was consuming about 3,500 kegs of beer per week, outside sources of beer would be needed, to be sure.

By the early 1900s, the Brown Hotel and the Seelbach downtown were in operation, as was a popular place called Mazzoni's. The growth concurrent with the influx of German and Irish immigrants and the rise of brewing was phenomenal. In 1858, there were just 56 saloons in Louisville, according to *The Encyclopedia of Louisville*; by 1898, that number had grown to 840. Many of these saloons were part of the breweries themselves, providing a place where the breweries could sell their products directly. In addition, much like today, breweries would court local saloons to sell their products exclusively, sweetening the deal by providing bar fixtures and décor, as well as glasses with logos—another practice that still goes on today through distributors.

Also, by the late 1800s, saloons and taverns had become places that would not only serve you beer but also feed you in the process. At some places, it was pickled eggs. At others, it might be a Limburger cheese and onion sandwich, a hot dog or even a pretzel. Mazzoni's on Third Street became famous for providing a rolled oyster as a snack to go with a five-cent beer.

In the Eisenbeis memoir, he spoke of a tavern in the early 1900s called Deckman's, which was "the most popular place for the medium class of people to stop and really get a free lunch with your glass of beer…He had forks in tumblers of water, so you could help yourself and fill up…It was the most popular place in town. It was always well filled with customers."

With the early 1900s came higher beer prices combined with ever-declining sales thanks to temperance and the oncoming Prohibition era, and the response by saloon and tavern owners was to no longer offer food as a complement to the beer. Barrels of common beer rose forty cents each and lager barrels eighty cents, and a January 3, 1917 article in the *Courier-Journal* describes the blow to the "free lunch": "Where now is exposed an elaborate array of delicatessen specialties, provided so the beer may have something to wash down, in the near future may be found only crackers and cheese, and where reposes the crackers and cheese now, very soon there will be only a memory of that which was."

Of course, it was the taverns and saloons that helped usher in the practice of "rushing the growler," wherein a person could take a quarter

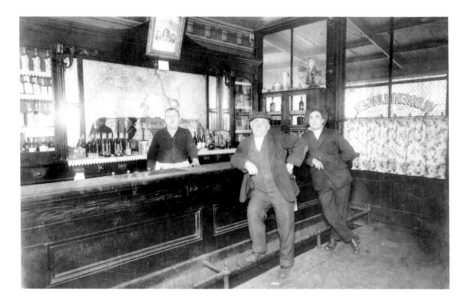

A look inside a Germantown-area saloon called Ash Street Station Tavern in what is probably the late 1800s. The men are identified as bartender Jacob Hartstern Sr., Mr. Brettinger and Mr. Gollar (or Gullar). *Courtesy of Tammy Ruff Scrogham.*

into a saloon with a pail and get it filled up for drinking at home. Parents would routinely send their children down the street to the local saloon to fetch a "growler" of beer. Heck, this practice resumed following Prohibition and lasted until bottled beer became the norm instead of draft in the 1950s and '60s. My father has fond memories of running to the corner tavern to fetch a growler of beer for his grandfather back in the late 1940s in Germantown.

Where the name "growler" came from is unclear; some have theorized that it was a term applied to a husband in a foul mood—only the bucket of beer would stop his "growling" at the wife and family. Other sources suggest that it was named for the growling standoff between a thirsty customer who wanted a full bucket of ale and the barkeep trying to pass him off with too much head. Still others say that the name comes from the growling stomachs of factory workers.

I interviewed a gentleman named Don Haag, who grew up in Germantown in the 1940s and '50s and rushed the growler on more than one occasion. While vintage photos show that most of these growlers are just simple metal buckets with a ridge around the top portion, Haag recalls his family having a growler with a lid, to keep the beer from spilling out.

"They looked like a small metal soup pot," he said. "Eventually they became stainless steel, with a handle and a lid that fits on top. It was nothing unusual." In Germantown, he said, there were a few schools of thought as to why it was called a growler. "One was the lid would fit down on it tight, and when the kid was walking back, the beer would slosh around and the gas would build up. And it would make a growling sound," Haag said. "Or, if they spilled any of it, [their father] would growl at them."

Eisenbeis rushed the growler a few times, and he recalled one evening when he his mission went awry:

> *Mrs. Ostertag owned a saloon at* [the northwest corner of Logan and Lampton Streets] *with her sister Alma Bierman as bartender, a very nice good looking lady. I never saw a man bartender there. I do not think they sold hard liquor. Finally, they wished to retire and Mrs. Ostertag sold to a Mr. Peters. He advertised about the big opening night of his new place; I remember he spent a goodly amount on renovating of the place and had a very good band* [Lochners' Band] *for opening night. I was quite young at that time and could not go in. My father sent me to go and get him some beer in the beer bucket, cost 5 cents. I was told to go to Henry Trauds' place which was across the street, but instead I went to Mrs. Ostertag's, now Peters' instead. The band played beautiful music and popular music of the day, then they started to play "The Holy City" and I went in and sang with the band. I knew the number and sang quite loud as I was a very good boy soprano. My father heard me from about ½ block away and came after me and took me home, with a very nice reprimand. Very likely the beer was flat.*

He probably was duly growled at as a result.

But the growler was more than just a vessel for keeping Dad happy; as I mentioned before, it wasn't long ago that the entire family enjoyed beer. Haag has a very specific and fond memory of his father's growler. "My dad would go down to Flabby's every night and get a soup pot of beer," Haag said. "He would set it on ice and sit on the porch and drink it."

Haag said that at some point on most evenings, his father would wake Haag and his siblings and call them into the kitchen, and they would all eat peanut butter sandwiches as snacks, along with a small glass of beer from the growler.

Hundreds of Louisville's taverns and saloons closed when Prohibition came in 1919 (officially enforced on January 16, 1920), but some remained

open, selling soda and food. Mazzoni's survived on its popular oysters. Many taverns were able to make a go of it by selling "near beer" (to be discussed later).

Fortunately, those that survived Prohibition were quickly joined by many new taverns, many of which still operate today. One of those is the Rush Inn on lower Brownsboro Road, which is thought to be one of the oldest operating taverns in the city. The structure was first built in 1885 as an inn and grocery, later becoming a tavern and then, ironically, converting to a Presbyterian church during Prohibition. After Prohibition, it was converted back into a bar with upstairs apartments.

Germantown remains a central hub for the city's taverns; beer bar Four Pegs was formerly known as the popular Taphorn's. The Highlands, where Zehnder's Garden and nearby Phoenix Hill Park thrived, is also home to a number of bars and taverns, popular places for Louisvillians to drink beer and dine, much as they were in the 1800s and early 1900s.

Ah yes, the beer. We've yet to talk about the beer itself, so we'll do that as our next stop on our tour through Louisville's brewing history.

WHAT WAS LOUISVILLE DRINKING?

We know that Louisville enjoyed an intense love affair with beer during the late 1880s and early 1900s, and we know that lager beer and "common" beer were the two main staples. But what did that beer taste like? That's nearly an impossible question to answer, in part because most of those early recipes no longer exist and in part because it would be impossible to precisely re-create the exact ingredients. Brewing is a science, but it is also an art; a good brewer adds subtle touches to set his or her beer apart. Those artistic touches died with those brewers many generations ago.

Louisville beer was often made with local water and barley, but hops were imported from East Coast cities, so it's difficult to tell exactly what those beers might have tasted like. But it can be presumed that the flavors were much stronger than the mass-produced beer that has dominated American palates for decades—probably to the point that the brewers of the day would laugh heartily if they tasted the corporate swill that so many people drink today.

Of course, beer wasn't necessarily welcomed by many whiskey-loving Louisvillians in the early days of its rise in the city. An 1868 article in the *Courier-Journal* describes beer like this: "Beer, as almost everybody knows, is an amber colored fluid, with a flavor peculiar to itself, which pleases some and is repulsive to others." The article cites that one writer "thought he had a parallel for the flavor…[likening] it to soap suds in which a pickle has been soaked."

Doesn't sound particularly accurate to me. Regardless, while we can't know for sure exactly what flavors Louisvillians were drinking in the late

nineteenth and early twentieth centuries, it's still fun to speculate, right? So that's what we'll do now.

Lager was probably the beer that was the second most quaffed in Louisville during the city's beer boom. Lager is a traditional German beer style that is distinguished not only by how it is made but also by its crisp body and flavor. Typically, a lager will taste quite a lot like the grains with which it is brewed, and it can sometimes taste "grassy" or like freshly mown hay.

But lagers also are hopped and malted, leading to varying levels of bitterness and body, depending on the types of hops and malts used and the amount. In addition, lager beer is fermented for longer periods of time than ale or common beer, as well as at lower temperatures. This production necessity made the brewing of lager beer difficult in days when ice was scarce or expensive, which is no doubt why Phoenix and other breweries created underground tunnels to ferment the wort to make this bright, crisp beer.

One can only imagine that if Louisvillians in the early 1800s were brewing and drinking primarily ales, stouts and porters, a first taste of lager with the influx of German brewers must have been quite a revelation—or perhaps a revulsion. A German settler named Joseph Jaeger was credited with being the first man to bring lager beer to Louisville in his 1901 obituary in the *Courier-Journal*. Jaeger died at age eighty, and although the short article does not reveal the year of his arrival, Jaeger is credited with having lager beer contract-brewed in Cincinnati and then delivered here. This could have been in the early 1840s, depending on the age Jaeger was when he did so.

During Louisville's brewing heyday, classic amber lager and darker lagers were brewed, with the body and color owing to the malts used. Guetig and Selle identified Phoenix Amber, for instance, as a Munich-style lager that would have carried a more intense flavor than the lighter, straw-yellow lager beers of the day. One would imagine that on a hot summer day at Phoenix Hill Park or Woodland Garden, the paler, crisper lagers would rule the afternoon, while the darker lagers might be more enjoyable on a chilly fall evening.

But the early breweries in Louisville made ales—one of them was Nadorff Brewing Company, which brewed beers that show up in advertisements of the day often as XXX Ale or XXXX Ale. The former was probably a hoppy, bold beer, probably about 70 or 80 IBU, two to three times more bitter than a lager, according to Guetig and Selle. The book also notes that porters and stouts of the early breweries probably were simply hoppier versions of what we know today, with stouts likely being as hoppy as the ales.

Brewery ads in the *Kentucky Irish American*, from October 29, 1904, show a variety of beers that Louisvillians were drinking at the time. *From the* Kentucky Irish American *archives,* newspaper.com.

Cream beer was another staple and was the cheap, light beer of its day. Lacking the bite of a lager beer, cream beer was just what it sounds like—light and smooth and less likely to get you drunk. This was no doubt a summertime favorite in the saloons. The cream beer that was hugely popular in Louisville is now known as Kentucky Common. Known merely as "common beer" at the time, it is basically a cream-style beer that was made with about 25 to 30 percent corn along with caramel and/or roasted malts for a dark amber hue and a bit more flavor than lighter cream beers. By the early 1900s, it was the most popular beer in the city; it is estimated that by 1915, 80 percent of the beer consumed in Louisville was common beer.

Conrad Selle provided me with this translated quote from the German-language newspaper *Louisville Anziger*, from 1909:

> *Beer has conquered the world. But one thinks…that this refers to lager beer. In Louisville, however, the beer drinker can enjoy double pleasure, as they can along with the lager beer enjoy the "common beer," a really great and increasingly popular product. It is a healthful, light, pleasant drink that people in other large American cities are for the most part unaware of. Perhaps its popularity, which it has always enjoyed here, would not be as great if, with improved brewing methods, better stuff had not become available. The best common beer in Louisville is the Cream Beer of the Butchertown Brewery.*

In fact, Kentucky Common is one that is occasionally replicated—or, rather, attempts to replicate it are made—by Kentucky breweries. Apocalypse Brew Works is one such brewery; it brewed a beer that is based on an Oertel Brewing Company recipe from 1912 (acquired by Selle from trademark owner Jan Schnur). That beer is smooth and lightly creamy, with a subtle tart finish and even a lightly toasty quality.

Selle said that the brewing logs kept by Oertel's master brewer, F.W. Finger, at the time suggested that he normally used refined corn grits in his common beer. "We could not get refined corn grits so we used corn starch," Selle noted, "which is pretty much the same thing. The steam kettles at Apocalypse are particularly suited to accurate replication of the mashing process, as they are also steam heated."

Of course, the point was not necessarily to use exactly the same hops, yeast and corn, as even with the recipes it's impossible to know the exact quality of any particular ingredient. The point was to simply make a beer that was as close as they could get: "I don't think we have to avoid the benefits

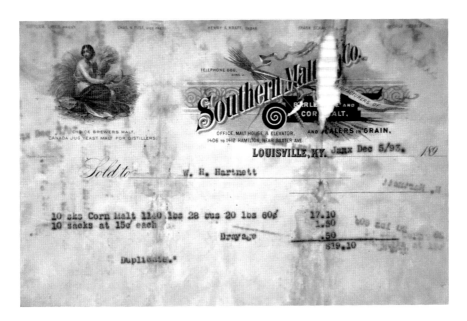

A malt bill dated 1893, from the Southern Malt Company to W.H. Hartnett. *Paul Young Collection; Jeff Mackey photo.*

of technical progress for obsessive authenticity—just make a unique style of beer that is good in its own right. Drinkability as a major part of its profile; it is a dark summer beer."

Lexington's West Sixth Brewing also brewed a Kentucky Common in early 2014 based on "principles" on which Kentucky Common beer was created in the early 1900s, according to a bartender there. The West Sixth version carried the same medium malt character but with a more assertive, almost Belgian-esque tartness and a finish that left a slight tickle on the palate after a few drinks. One note, however, is that the West Sixth version was 8 percent alcohol by volume (ABV), which wouldn't have been the case for an early 1900s "session" beer.

Great Flood Brewing, one of the newest Louisville breweries as of this writing, collaborated with Bluegrass Brewing Company, the city's oldest existing brewery, on a Kentucky Common that was quite like the West Sixth version, although with a more authentic 4.8 percent ABV. It was drinkable, smooth and carried a slight tartness that bordered on sour. It's worth it to try a Common just to revisit what Louisvillians were drinking as many as 150 years ago, as well as to enjoy one of only a few beer styles indigenous to America.

But back to the lagers. One of the most-loved German beers in Louisville in the late 1800s and into the mid-twentieth century was bock, a lager made with dark malts and fermented for months instead of the weeks needed to make standard lager. The result is a thick, hearty beer with about double the alcohol content of a typical lager.

Bock beer was released in the spring in German communities to coincide with Lent, in part to provide a meatier beer in which to partake during Lenten fasting. But the celebration of finally being able enjoy the fine beer that had been aging for most or all of the winter was reason enough for Louisvillians to get excited. "Bock Day," as such, was as much a holiday in Louisville, at least for its German residents, as in Germany. People would take the day off work, newspapers would excitedly report the coming release of the beer and posters and advertisements bearing the likeness of a goat—*bock* being the German word for goat—would appear all over town.

The newspaper reports would usually recount the legend of how bock beer was born, which in a March 21, 1914 *Courier-Journal* article went like this:

It is legend that Jan Primus, or John First, whose name has come down to present times as "Gambrinus," had a vagabond serving man who ran away from his master and carried with him two stone bottles of beer with which to refresh himself on his travels. He drank the first bottle of beer and then buried the other until he required it. But he wandered far and it was not until hunger drove him homeward that he came on the place where he had buried the bottle of beer.

It had had several months in which to ripen, or "lager," and the serf was delighted and surprised to learn that it had greatly improved in quality and flavor, and being a wise knave, he saw his chance to make favor with his master and escape the punishment which he rightly anticipated.

Accordingly, the runaway took the bottle of lagered beer to his master and was not disappointed at the pleasure that the king found in the discovery. The result was that Gambrinus had his castle brewer put away a lot of beer every winter to ripen, and thus he became the patron saint of the ancient and honorable Guild of Brewers.

Whether this tale bears any truth is irrelevant; the fact is that bock beer today is still celebrated in the spring in many cities—although, sadly, no longer in Louisville—with rich, dark bock beers made available per tradition.

A 1903 newspaper description of the beer described it as having a "particularly grateful sweetness that is highly appreciated by the beer

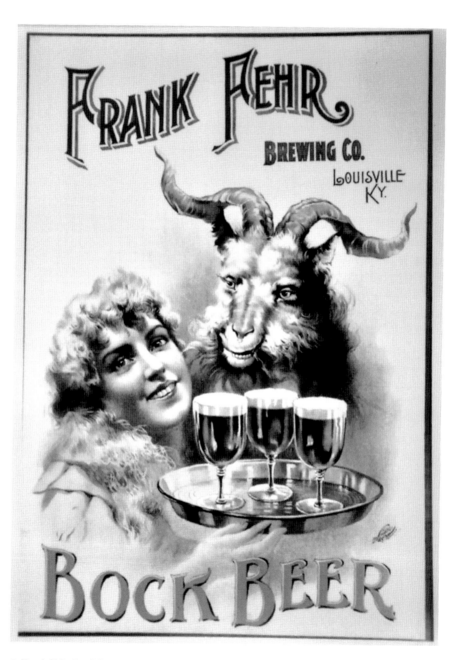

A Frank Fehr bock beer sign. *Paul Young Collection; Jeff Mackey photo.*

drinker." Additionally, a 1910 newspaper story notes that bock typically packed 7 to 8 percent alcohol by volume, which was enough to "make an excessive indulgence a trifle dangerous to those who are not accustomed to malt beverages." That the standard lager of the time was closer to 4 percent ABV is a fair reason why bock tended to bring out the worst in some.

I enjoyed a bock beer in March 2014 at Hofbrauhaus in Newport, Kentucky, and it was a dark, rich, almost chocolaty beer with great body and quite a kick. When I ordered the bock, I told the server, "Just a small one, not the forty-eight-ounce."

She replied, "Don't worry, the small size is all we serve."

The bock beer I enjoyed, which was 8 percent ABV, is no doubt similar to the bock that Henry Caldwell and Mary Smith were drinking on March 18, 1894. The couple apparently enjoyed several bock beers that day, according to a police account, and decided to make a living, breathing bock beer sign to celebrate their enthusiasm for Bock Day. However, as they couldn't find a goat, they instead stole a pig and apparently tried to paint the poor animal into a sign near the corner of Ninth and Walnut Streets.

"The beast objected loudly," according to the report, "and disturbed the services of the colored church near by. Officers McPeak and Hessian arrested all three. The pig was sent to the West End pound, and the man and woman to the station house. They told different stories about how they came into possession of the pig." One wonders if the police officers themselves had hoisted a few bocks that day, given that they arrested a pig.

But these sorts of stories were common finds in my research into Bock Day in Louisville. From mudball fights to broken windows and hatchet attacks, it seems that the long winter of drinking lighter beers and lingering indoors left many Louisvillians unprepared for the punch in the brain that the bock brought with it.

Now that we've had a taste of what Louisvillians were drinking during the city's brewing boom, let's take a look at a few of the more prominent breweries of the day.

RISE OF THE BREWERIES

So many breweries opened, closed and changed hands between the mid-1850s and Prohibition that it's a mind-boggling chore to try and make sense of it all. Somehow, Guetig and Selle managed to do it, but let's keep this study a bit simpler. We'll take a look at some of the more notable operations, particularly the big three—Frank Fehr Brewing, Falls City and Oertel Brewery—which were the only three that would ultimately survive Prohibition after years of brewing.

Before we get better acquainted with the three key breweries that survived, though, we'll take a look at those that didn't yet were still important operations during the rise of Louisville brewing. There were many of them; Guetig and Selle wrote that since Louisville was founded, more than two hundred brewing operations have existed.

The early breweries were small operations that, like the neighborhoods these German immigrants were building with their own hands, resembled those from their homeland. As noted previously, German immigrants did not leave their homeland on a wing and a prayer; often, these breweries were operated by the owner and his family, along with a few hired men who were from the owner's home village. Often there was an attached saloon, and in many cases, the owner's family lived on the property as well.

Louisville Brewery, founded by a Scotsman named Hew Ainslie, was an early brewery that was founded in the late 1820s. Metcalfe & Son's Brewery opened in 1932. It was owned by an English family and was actually based in Cincinnati, but it opened a Louisville brewery on Market Street between Sixth and Seventh.

In *The History of Louisville: From Its Earliest Settlement 'Til the Year 1852*, a passage (that actually appears to be an "advertorial" type of advertising) notes that Metcalfe & Sons was

> [e]*qual in point of size and capacity to any in the West. The long practice in this manufacture which the senior partner of this firm has had, and the well-known reputation of the establishment are sufficient proofs of the quality of articles manufactured here. Situated in the centre of a splendid grain market, with water equal to any in the world, and with thoroughly practiced and competent workmen, the Louisville Ales, Beer, Brown-Stout, [etc.], cannot be anywhere surpassed. The Brown-Stout from Metcalfe's Brewery is fully equal in every respect to the London article; and the experiment of placing it, in Byass' bottles, before the best connoisseurs has been frequently attempted, and always with success. It has, however, a reputation of its own and does not therefore need a foreign stamp to make it currently received. Beside furnishing the interior of most of the western States, Messrs. M. & G. find a very extended and ready market for articles of their manufacture in the larger cities. Memphis and St. Louis receive and sell large quantities of these articles, and scarcely a boat leaves for the Tennessee or Cumberland rivers without having among her freight more or less of the products of this brewery. Cards announcing the presence of these articles for sale are every where shown out as inducements to the lovers of these delightful beverages. In Louisville the brewings of Messrs. M. & G. are highly valued by all.*

Another early notable brewery opened in 1848: the William Tell Brewery, on Green and Liberty Streets between Preston and Jackson Streets. Not only was it one of the first German breweries, but it also would later be purchased by Frank Fehr (to whom we will devote an entire chapter later).

William Armbruster's Washington Brewery would also open during or around that year on East Jefferson, and from there, it was off to the races: Jackson Street Brewery, P. Merkel's United States Brewery, Star Brewery, Peter Schmitt's Brewery, the Walter Brewery and Walnut Street Brewery—Louisville was bursting with beer.

A similar swelling was happening just across the murky Ohio River in southern Indiana, as well. Indiana Brewing Company went through several ownership changes, but it brewed between 1847 and 1899 in New Albany. Another early New Albany brewery was Bottomley and

An undated photo of Reising Brewery workers. *New Albanian Brewing Company Public House Collection.*

Ainsley Brewery, launched by Hew Ainslie and a partner. It lasted less than two years, however, before being destroyed in a fire. In addition, City Brewery opened in New Albany in 1842 (according to the website IndianaBeer.com). Another City Brewery (later City Brewing) would open in Jeffersonville in 1875.

Further, Market Street Brewery opened in 1856 in New Albany, followed by Spring Brewery in 1865. In addition, New Albany's Metcalfe Brewery was purchased by Paul Reising, an immigrant from Bavaria, who reopened it as Reising Brewing in about 1857.

The *Courier-Journal* provided an overview of Louisville's brewing industry in 1893 with a two-page spread bearing the headline "Louisville Beer Barons." It's an apt title, and it enthusiastically (almost to the point that it also may have been "advertorial") identified major players during Louisville's brewing heyday, as well as, perhaps more importantly, the conditions in and around Louisville that made the city such a perfect spot to become "a great brewing center."

The article cites favorable railroad rates, affordable land, the low price of labor, the excellent location (presumably as a hub among large cities like Indianapolis, St. Louis, Cincinnati and Nashville) and the water in Louisville, which was "regarded by those who ought to know as being unexcelled for brewing purposes."

The uncredited writer also cites the city as being similar to Trent, England (where Bass & Company is located), for its natural water resource and climate, both helping to make Louisville superior to many other cities for possessing the resources to brew quality beer. "The lager beer of Louisville must sustain its reputation for purity at any cost," was the motto of local brewers in the 1890s. And while competition in the city was fierce, the story notes that if any Louisville brewer would attempt to cut corners and make a cheaper product, this competition would no doubt pressure him to change his approach or "retire from the business." (This would actually begin to play out during the latter part of the brewing heyday, with the rise in cost of materials and resulting war with taverns over rising keg prices.)

But competition also came from those aforementioned nearby cities, and Louisvillians by and large stayed true to the home product. What we'll find later is that this stayed true right up through the 1940s and 1950s, before big marketing budgets in St. Louis and Milwaukee would slowly but surely strangle the smaller American brewers.

But before the brewing operations in Louisville were quieted, the city's breweries enjoyed a boom, particularly in the latter half of the 1800s. Guetig and Selle noted a 1,000 percent increase in the number of barrels brewed in Louisville between 1863 (52,111) and 1902 (534,750), in part a product of ever-improving technology and industrialization.

From that aforementioned *Courier-Journal* spread, here are some of the brewers that were major players at the time.

SENN & ACKERMAN BREWING COMPANY

Senn & Ackerman, founded by Frank Senn and Phil Ackerman in or around 1878, went from producing fewer than 6,000 barrels in its first year to producing 44,560 barrels in 1892. Originally simply called Senn & Ackerman, the "Brewing Company" was added after the business incorporated in 1892.

An Ackerman Brewing Company bottle. *Private collection; Rick Evans photo.*

Senn was listed as a driver for California Brewery in 1856 and later worked for another brewery, but he was determined to open his own brewing operation. He leased Boone Brewery in 1869 with an early partner and later went into business with Ackerman, a skilled brewer who had worked for Phoenix Brewery and others. The Senn & Ackerman brewery was located between Seventeenth and Eighteenth Streets between Main Street and Pirtle Alley. The brewery also owned an adjacent park (a small beer garden, perhaps?), and the iron, brick and stone structure included a 125-foot-tall tower.

According to the *Courier-Journal* account, Senn was well known for his integrity and business savvy. "I consider that the brewing industry of the United States is still in its infancy," he told the newspaper. "I have no fear as to the future of Louisville as a brewing center."

Interestingly, he extols the healthful virtues of beer in his words to the reporter, even throwing in a passing shot at the temperance movement of the day, saying that "most careful analysis by a Board of Health would fail to find anything that is injurious to health. The brewers are in one sense physicians, and they are well aware of the great power for good which they wield. Depend upon it, American men and women would not have adopted lager beer as a national beverage—millions favoring it—if it had not been a temperance drink."

Senn died in 1913, and the Senn & Ackerman brewery, which had joined a monopoly called Central Consumers Company with Fehr, Phoenix, Schaffer-Meyer and Nadorff Breweries, closed three years later. The brewery was later demolished.

Phoenix Brewery

We've already shone a spotlight on Phoenix's impressive beer garden and entertainment complex, but none of that could have existed without the well-regarded beer being produced at the brewery owned by Peter Weber, who was proprietor of Union Brewing in Madison, Indiana. Weber's son, Charles, was president of Phoenix.

The brewery complex at this time occupied a frontage of 560 feet and a depth of 1,000 feet bordered by Baxter Avenue, Barret Avenue, Payne Street and Rubel Avenue, and the story reports that in the previous eighteen years, $175,000 in improvements had been made. At the time, Phoenix brewed three beers: the Bohemian, the Wurzburger and the Lager, all of which were

lager styles. But Phoenix also brewed bock, common (or "Komon") and some ales as well during its impressive run.

Opened in 1865 and incorporated in 1883, the brewery was led by a team of staunch businessmen and brewers from around the region. Moreover, it was one of the largest and best-known breweries, in part because of the park that drew national attention.

The anti-beer backlash associated with the coming of Prohibition forced the brewery to close in 1919, and Guetig and Selle wrote that the Frank Fehr Company operated a mushroom farm in the huge underground beer vaults beneath the park. As noted previously, the facility fell into disrepair and was mostly gone by the late 1930s.

The only piece left of the Phoenix complex is the muraled, gray horse stable at 508 Baxter Avenue.

SCHAEFER-MEYER BREWING COMPANY

This German brewery was founded in 1881. For a time, it was called the Shelby Street Brewery, and by 1890, it had moved to a new location at Logan and Lampton Streets that reportedly cost $315,000 to construct. Founded by

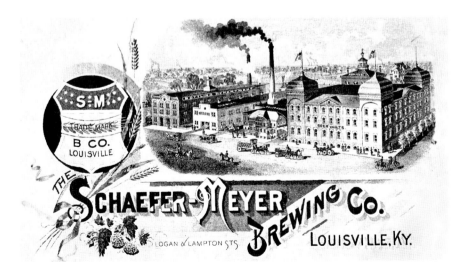

A promotional card for Schaefer-Meyer Brewing Company. *Private collection.*

Charles A. Schaefer, John Kirchgessner and Henry Krupp, change came quickly, as Kirchgessner departed to open the aforementioned City Brewery in Jeffersonville.

Adolph Meyer, who had been brewmaster at Phoenix, then joined forces with Schaefer to create Schaefer-Meyer. Krupp died in December 1890, but the *Courier-Journal* account notes that his estate at that time remained invested in the brewery, and George Krupp, his son, held an office in the company.

Interestingly, the brewery backed up to the Louisville & Nashville Railroad, which made shipping and receiving a huge asset for Schaefer-Meyer. At the time, the beers produced were the Empire and the Lager, but Guetig and Selle also cite Cool Blonde, which probably was a light cream ale, as well as Berliner Weiss (weiss beer), a sour wheat originating in Berlin—perhaps owing to brewmaster Otto Doer, who joined the brewery in 1893.

After joining the Central Consumers Company, it later became a brewing plant for Frank Fehr and was converted into an ice and storage company when Prohibition started. Much of it still stands and was until the 1990s occupied by the Merchants Ice & Storage Company.

Joseph Stein Brewing Company

Also known for several years as Joseph Stein & Company's Southern Brewery, Stein was established in 1876 by Joseph Stein and his three German brothers—based on accounts at the time, his brothers were big, strong men who were "so endowed that they can lay hold of impediments and obstructions which to most men would seem impossible to surmount."

Stein worked in breweries in Cincinnati and St. Louis before settling in Louisville at Otto Brewery (later Frank Fehr Brewery) and living until 1892. Henry Rueff took over as president and was as defensive as other brewers of the day of the product Stein Brewing was creating. "I am satisfied that no other drink can be devised by man that will be the peer of lager beer as a popular beverage," Rueff said. "Depend upon it, lager is here to stay." (Take *that*, temperance.)

Stein was located at 1025 East Green Street, between Wenzel and Garden, and was originally established by Adolph Peter in 1848 before becoming the Green Street Lager Beer Brewery. It was one of the first in the city to add the most modern "Arctic" ice machine.

However, Prohibition would not have a direct effect on Stein, as the company went bankrupt in 1900 and never recovered.

CHRIST BREWERY

Christ Brewery dates back to 1869 and was located, according to Guetig and Selle, in the former location of Armbruster's Washington Brewery on Jefferson Street, before later moving to the 500 block of Baxter Avenue, probably not far from the current Baxter Avenue Baptist Church at Hull Street.

Proprietor Michael Christ was German-born and lived in Louisville by age nineteen. The brewer was known as Christ and Son in the late 1890s and later Christ and Sons (although the *Courier-Journal* listed it as M. Christ and Sons). At the time of the "Beer Barons" story's publication, Michael Christ was considered the oldest living active brewer in the state of Kentucky.

In the early 1890s, Christ was moving away from the common cream beers and focusing on lagers, probably because of temperance and lager's increasing reputation as a temperance drink; it was also producing a lager known as the Export.

Following Christ's death in 1896, his sons took over. By 1914, the company had become simply Christ Brewing Company before closing in 1918 for the same reasons most of the other breweries were closing at the time.

NADORFF BREWING COMPANY

Located at 1544 Portland Avenue, Nadorff was operated by Henry (actually Heinrich) Nadorff, who also invented an ice machine that was used at the brewery. A German-born brewer, Nadorff came from generations of German brewers dating back three hundred years. The five or so generations, the article notes, may well have made him the brewer with the longest heritage in the profession.

He first settled in Baltimore and then Cincinnati en route to landing in Louisville in the late 1860s. He was involved in several other small breweries before launching his own in about 1892 on the site of a long-vacant operation.

It became known as the "cream beer brewery," but after procuring an ice machine, it began brewing lager. Guetig and Selle noted that by the late nineteenth century, Nadorff was also brewing the XXX Ale, which they surmise was a strong, hoppy beer similar to an India pale ale.

It would become the smallest of the five breweries that composed the Central Consumers Company; the brewery closed in 1904.

Again, these are some of the more notable breweries in Louisville during the city's brewing heyday; many more came and went, and interestingly, brewing here was a fairly tight fraternity, with brewers and brewery workers moving about from place to place over the years. The truth is that it probably was much like brewing in Louisville today, which is a tight fraternity in which brewers not only know one another but also help out one another whenever necessary. Granted, today's brewing scene is much, much smaller, but the principles today are similar to those from the late nineteenth century—well, excepting the emergence of the Central Consumers Company.

One of the questions I asked when I began writing this book was this: what was it like to work inside these breweries?

THE BREWERY LIFE

The first task a Louisville brewery worker would tend to when reporting for a shift was to test the most recent batch of beer. In all likelihood, this was a robust specimen of a man—perhaps a tad beefy but strong—who spent much of his day lifting heavy barrels and kegs. Upon reporting to work or during breaks, he would walk into a cooling area to the "home bar," a place where workers could get a glass of fresh draft any time of day.

The workers would gather around a polished oak bar, behind which normally rested two ornate, oaken keg cases. As soon as a keg would blow, another was retrieved, and this kept up the entire day. If a keg somehow didn't empty within an hour's time, the remains were discarded and a fresh keg was fetched.

Behind the bar was a worker whose job it was to make sure that his co-workers were kept with fresh beer at all times; one can assume that he was likely the most popular man in the brewery. Rarely, if ever, was there a time when there was not someone waiting at the bar for a fresh glass of beer. The brewery workers never paid a dime, and each man was allowed to drink his fill during his shift, which, on a weekday or Saturday, could be twelve to fourteen hours long.

According to an 1891 news story, one Louisville brewery (which, oddly, was not named) employed seventy men and estimated that it went through between eight and twelve kegs per day—this doesn't exactly match the reported workday of the era, if the fresh-keg-every-hour assertion is, in fact, true.

A Falls City brewery worker hauls a barrel on a handcart. *Dave Easterling's Falls City Collection.*

Of course, some men drank no beer on the job, and few were ever seen to be intoxicated. The grueling work and hot temperatures, especially during summer months, no doubt helped them metabolize the beer so quickly that they scarcely felt its effects. In fact, in July and August, it was reported that on some days workers in this particular brewery would go through as many as twenty-five kegs in a day's time—particularly those on day shifts. (Breweries generally operated around the clock.)

There was pride and prestige in being able to drink the most glasses of beer without showing signs of intoxication, and rivalries among co-workers were common. Some of the hardier men could reportedly drink twenty-five glasses of beer per shift—a few were even known to drink fifty glasses per day for as much as a month at a stretch, which is mind-boggling, especially considering modern society's health recommendations of no more than two to three beers per day.

Workers boarded and lived at many of these breweries; others lived in boardinghouses nearby. The smaller breweries were typically family operated, which meant that the workers would be fed meals during the day. In the 1860s, brewery workers made only twenty or twenty-five dollars per month, per Guetig and Selle. Unionization later in the century increased that a bit, and by 1917, the set minimum had become twenty-one dollars per week; unionization also reduced the workweek to eight hours per day, six days per week.

Much like today's brewery taprooms, people could come in with "beer checks," presumably purchased from taverns, and have a glass of fresh beer at the breweries. This particular newspaper report noted that "those policemen whose beats are around the breweries are always fat, as they have entrée at all hours."

While the speculation of these brewery workers living shorter lives than most due to damage to the liver and other organs was pervasive even in the day, the general feeling among these workers was that "as long as life lasts, it is pleasant." However, as stated previously, beer was so much a part of life that it wasn't just the brewery workers who were given beer during the workday. In Eisenbeis's aforementioned memoir, he noted that he lived near Sengel's Cooperage Works, where whiskey barrels were made. "It was my job to gather chips from the place to take them home so we could start our fires in our stoves and I filled up our coal shed with as much as possible," he wrote. "Mr. Sengel was kind to his men and allowed his men to have beer during working hours. One of the men had a long stick with about 10 buckets hanging from it and would go after the beer maybe several times a day."

A column in the *Courier-Journal* called "Matters of Common Talk" offered an interesting aside in 1894, relating that one evening, a friend of the writer happened by a brewery and noted a number of young men gathered inside. He walked inside and was offered a beer at the bar that was set up for the brewery workers. "It was strange how quickly people will learn where they can get something for free," the column reported. "Soon several other men arrived. They said they wanted a $1 keg of beer and wanted it delivered. There were five men in the party, and each was given two glasses of beer for nothing. I could not help think[ing] only one of the men could have ordered that beer, or that he could have even telephoned that order, considering that the weather was so hot for walking."

Sometimes free beer was even easier to come by. On June 18, 1895, unused barrels of beer from New Albany's Indiana Brewing Company on Eighteenth Street were designated for dumping, so they were dumped in the street—all 1,800 barrels. The beer began to run toward the Ohio River, and the streets literally ran with beer for hours. Nearby residents descended on the frothy, golden river with cups and buckets and drank to their hearts' content. According to the news report, "Many of the voters in the First Ward were comfortably drunk before midnight."

However, breweries could also be dangerous places to work. In August 1883, a boiler exploded at J.L. Abrahams's brewery, which was located on Hamilton Avenue near Baxter Avenue. The boiler, which was six feet tall, smashed through a wall, flew two hundred feet in the air and then crashed into a nearby shed. No one was injured, but the boiler house was destroyed; the owner and his engineer had walked away from the boiler only moments before the explosion.

About a year and a half later, a boiler exploded at Schneider Bros.' brewery, near Seventeenth and Kentucky Streets. When people nearby heard an explosion, they ran to the brewery to find that a boiler had exploded and been thrown twenty-five feet, badly damaging the brewery and injuring several. Brewery worker John Busch was injured and trapped by brick and other debris that rained down on him, and the boiler itself came to rest on top of him, crushing his abdomen and thighs. Meanwhile, three children playing nearby were injured by flying debris; one of them, eleven-year-old Rudy Tamling, was trapped under debris and scalded by the boiling water.

In March 1889, a well digger at Hartmetz's Brewery on Story Avenue was injured when a beer wagon passing the well broke through some planks and knocked Stephen Roth and Francis X. Metzmeyer into the eight-foot-deep

well. Metzmeyer was knocked unconscious, but Roth managed to keep his workmate from drowning in the well.

Schaefer-Meyer was the scene of an explosion the following August that, as the news account noted, "shook the immense building from cellar to garrett."

While most of the brewery workers fled immediately, worker Steven Kettler was later found wedged between two casks, having been knocked there by the blast. Kettler was presumed dead by his co-workers, as he was unresponsive and bleeding from the nose, mouth and ears, but once he was removed from between the casks, he regained consciousness. However, the story reported that he was taken to the hospital and that "there appears little chance of his recovery." I could not find a follow-up story about Kettler's fate.

In March of the next year, a brewery worker named Louis Ulrich was badly injured when the Jeffersonville Brewery was robbed. Ulrich said that he was in the brewery office when five men entered, and one said something to him in German. He figured that it was a request for beer, but instead the man pulled a revolver, and one of his cohorts suddenly began beating Ulrich with a piece of rubber air-brake hose. He tried calling for help, at which point another man stuffed rags into his mouth. After a few more blows to the head with the hose, Ulrich lost consciousness. Before that, however, he claimed that he heard one of the men say, in English, "Let's finish him or he'll squeal." Luckily, that man's opinion was in the minority. The men proceeded to blow open the brewery's safe, and Ulrich eventually recovered from the beating.

Perhaps the most tragic story, however, occurred on July 5, 1892, at Sebastian Bott's Brewery, located at Eighteenth and Lexington; brewery worker William Ochs arrived at work that day to find co-worker Max Benz emerging from the cellar, strangely holding a pistol. Benz jokingly pointed the gun at Ochs's head and said, "I'm going to shoot you dead"—then the gun went off. Ochs collapsed, bleeding.

A shaken Benz ran for help, but Ochs's wound appeared to have killed him or at least mortally wounded him. While the other brewery workers were tending to Ochs, they heard another gunshot, this one from the second floor of the brewery.

The *Courier-Journal* story relates this grisly scene: "A number of people ran up the stairs and found Benz lying dead on the floor. From appearances, he had rushed upstairs as soon as he saw what he had done, seated himself on a trunk, loaded the revolver and fired the shot. He placed the muzzle in his mouth and pulled the trigger. The bullet crashed through his head, bringing instant death."

Kenneth Schwartz at Falls City, circa 1950s. *Courtesy of Kenneth Schwartz.*

At times, sadly, the free beer that so many managed to enjoy at work without issue became a problem for others. A Phoenix Brewery employee named Xavier Weishar committed suicide in a Louisville jail cell in November 1881 by cutting his throat. It was his fourth suicide attempt. The news report of his death noted that he was a hard drinker who had frequently suffered from delirium tremens. Not long before his suicide, he had been on a binge and had taken up an axe, running around the brewery smashing things and screaming that rats and snakes were chasing him.

Interestingly, the policy of offering free beer to brewery workers continued after Prohibition in at least one of the breweries. Kenneth Schwartz—a tall, lean, gray-haired man with soft brown eyes—worked at Falls City Beer for thirty-eight years beginning in 1941, and he recalls that a locker room in the brewery for employees had a refrigerator stocked with bottled beers.

But early in Schwartz's time at Falls City, it was mostly draft beer that was produced, and that's what the workers drank. At that time, Schwartz worked in the boiler room, which subjected his co-workers and him to almost constant heat. "When I first went there they had a little place right across from where they did the plumbing, and there was a little shed there," he recalled during an interview for this book. "The guy would give you a

beer. One time I went up there, I come out there and didn't have a shirt on, because that damn boiler room would get hot. I went over to get a beer, and he wouldn't give me one."

Schwartz's boss was nearby, and as Schwartz walked away, the boss said, "Ah, hell, what's wrong with him?"

"I said, 'He told me I can't have a beer 'til I put a shirt on,'" Schwartz recalled. "The boss jumped all over him. He said, 'I don't give a damn if they come out here *naked*, you give them beer!'" And then Mr. Schwartz—clad in a white, collared shirt, dark blue jeans and suspenders on the day of our interview—laughed and told me, "Hell, he could have refused me beer anyway. I was underage."

At times, he said, his co-workers would also simply take a one-gallon can up to the tanks to retrieve draft beer by dunking the cans into the tanks. "That wasn't supposed to happen," Schwartz said. "I went up there one day and almost got caught by the brewmaster. I left my bucket there and took off."

Even in Schwartz's era, the work was demanding, and there were times when he would work twelve-hour shifts, seven days a week, when the brewery would get understaffed. But he recalled that the management was fair, if strict. "Those are some of the best memories of my life," he said. "It was the best job I ever had because you learned stuff all the time. There was something always going on."

We'll hear more from Mr. Schwartz later in the book. Now let's take a look at the years leading up to Prohibition.

TEMPERANCE AND THE ROAD TO PROHIBITION

Prohibition hit Louisville, in a way, many decades before it became a national law. In the year or so following the Bloody Monday Riots, the Louisville City Council became occupied primarily by those who supported the prohibition of alcohol. Once that happened, following the Election Day riots in 1855, the council quickly stopped issuing liquor licenses, which were required by law to be renewed annually.

At the time, there were nearly five hundred liquor retailers in the city, according to *The Encyclopedia of Louisville*, and their response to the council's action was, first, to continue serving without a license, which many did in spite of ongoing fines, and second, to take the matter to court.

Jefferson Circuit Court judge William F. Bullock sided with the liquor-license holders, and the council promptly appealed. In fact, seven councilmen refused to honor the judge's decision and spent a few days in jail before the Kentucky Court of Appeals quickly overturned Bullock's ruling. (Apparently, the wheels of justice turned much more quickly in the mid-1800s than they do today.)

After months of battles between saloon owners and the city council, on March 29, 1856, it was put to a vote by the people, and the right to obtain liquor licenses won by more than one thousand votes. Louisville's self-imposed "Prohibition" was over for the time being, and the temperance movement began to fade, leading to the brewery boom of the second half of the nineteenth century.

But temperance didn't go away quietly; while the original movement was led primarily by men, it was women who would carry the torch, and

by the 1870s, temperance ideologies had begun to pick up steam once more. For a time, beer was thought to be the answer to temperance, with its lower alcohol content and wide consumption by men, women and children alike.

In 1868, the *Courier-Journal* noted:

> *Statistics show that since the use of beer has become so general, the demand for whiskey, brandy, gin, and all other strong liquors has gradually diminished. It may appear like fighting the devil with fire, and a little paradoxical, but it has done more to suppress disgraceful dissipation than all the temperance orders in the country. It is, therefore, a great temperance missionary. If every man and woman that is arrested and put in our jail and station-houses for being drunk and disorderly were questioned as to the kind of liquor they had been using, it would be developed that not ten out of fifty could charge their troubles to beer.*

This is another way in which Louisville easily could have become a beer city in a bourbon state—temperance leaned toward beer and away from whiskey, at least for a time. But that memo apparently didn't reach Frances Willard and Carrie Nation (who later dubbed herself "Carry A Nation," a trite and self-righteous pun), the axe-wielding, Bible-thumping Kentuckian who helped bring the temperance movement its national momentum; soon the call to ban the production and sale of alcohol was back on.

In the late 1800s, a twice-divorced Nation, who had moved west, joined an organization called the Woman's Christian Temperance Union, and the crusade was on. It isn't precisely known where her hatred for drinking was born, although apparently she claimed that her first husband was an alcoholic.

Nation was well known for walking into saloons unannounced with her hatchet and Bible and going to town on anything she could destroy. Many sources say that since she was an elderly woman by this time (she was born in Garrard County, Kentucky, in 1846), men were hesitant to use force to stop her. It was also reported that Nation was close to six feet tall and nearly two hundred pounds, which may have been a deterrent as well. She basically committed "terrorism in the name of Temperance," as one writer put it. In fact, at one point, Nation would go on a saloon-attacking binge in Elizabethtown, a town about forty-five miles from Louisville.

Nation passed away in 1911, but not before helping push temperance toward eventual nationwide (or perhaps *Nation*-wide) prohibition. The *Courier-Journal's* Henry Watterson wrote after her death, "Did she really

Carrie Nation, probably in about 1900. Yeah, she was not to be trifled with.

suffer from the hysteria into which she threw herself, or did she enjoy the excitement and notoriety? Who shall tell? Poor old hag! Peace to her ashes."

Whether Nation truly believed in her quest or was simply a proto-PETA style of radical, we'll never really know. However, there are still roads named after her in Kentucky, so there apparently were or even still are believers. (It should also be noted that there are a few bars named after her across the country, a fitting "tribute.")

It's interesting to remember, however, that during this time, beer was still gaining in popularity, not just in Louisville but across the country as well. As we learned earlier, by the late 1800s, Louisville was buzzing with beer gardens and enjoying the products of dozens and dozens of breweries in both the city and in southern Indiana. But temperance was felt nevertheless. On one hand, the breweries were fighting the ever-growing rise of unrest among laborers wanting better hours and wages, yet they also fought the rising prices in materials and the expected backlash from saloons and customers when prices rose.

The Woman's Christian Temperance Union soon had an ally in the Anti-Saloon League, or Dry League. Sunday "no liquor sales" laws that had largely

been overlooked soon were being enforced. Alcohol laws and prohibition were being debated in the newspapers, by politicians, in churches and all across the city. Women who supported prohibition adopted the slogan, "Lips that touch liquor shall not touch ours," forcefully holding men's feet to the fire on the issue.

At times, political leaders of the same party would take opposite stances, dividing their supporters on the issue. But more than anything, the pervasive negative view that society seems to take now toward beer and its role in everyday life was beginning to take hold at this time.

Think about it—the late 1800s in Louisville was a time when brewery workers drank beer freely on the job. Many employers allowed their workers to do the same. At times, beer was drunk before breakfast, at lunch and at dinner—all day, in fact, and by all members of the family in some cases. But today, most employers, if they learn that you had a single beer with your lunch, will terminate your employment on the spot, no questions asked. In my mind, this time in history was the real birth of that feeling, as propaganda erupted that pointed to the evils of alcohol of all kinds, using extreme examples to make points. Sure, alcoholism existed then, and the concerns are understandable. One of the more interesting, and perhaps disheartening, bits of information I came across in researching this book was the story of Louisville's "keg tippers."

Just how much of this is blown out of proportion for the sake of pushing forth an agenda will never be known, but an account in the *Courier-Journal* in September 1890 related stories of those so desperate for sips of beer that they would roam the streets from saloon to saloon, testing the discarded barrels that had been left in the street for pickup the next morning by the brewery carriages making their rounds. If any beer were found to still be inside, they would pick up the barrel and empty what they could into a bucket or some other vessel.

The unnamed writer of the story observed a young boy tipping kegs and noted, "The lad kept along in the shadow of the houses, as if ashamed of what he was doing, or to avoid unwelcome observation." However, as his bucket grew fuller with each stop, the boy would occasionally drink from it, apparently to get his share.

"Presently he darted into an alley, in the darkest shadows of which could be seen the outlines of a woman. 'Did you get any?' she exclaimed as the boy approached. His only answer was to hand her the bucket, which she took to her lips and drank until the last drop was gone." The woman then "begged" the boy to go on another "foraging tour," the writer claims, at which point the

boy responded, "I am tired." She continued to prod him, and dutifully, the boy continued on from saloon to saloon.

In fact, this apparently was a common occurrence in the streets of Louisville. The writer asserted that these "degraded wretches" would actually divide up territory so that each had ample chance to get his or her fill. Children often were the ones lifting the heavy barrels to retrieve small amounts of beer at a time for their parents late at night, while some were likely homeless individuals who would retrieve the free beer by night and sleep in some darkened alley by day. Local police even had a name for them: the "Beer Tippers Association."

Of course, some kegs would yield only a few drops, but the effort of picking up an empty barrel and shaking it for its contents was just as strenuous as tipping one with half a gallon of half-stale beer in it. The writer mentioned one keg tipper by name: Bill Johnson, who had a stick that he would plunge into the barrels to test how much was left in the bottom. He would then make a chalk mark on the head of the barrel, and a following assistant would pour the beer into a bucket, if indeed there was any. The longer the mark Johnson made, the more beer was inside, giving the assistant tipper notice of how large of a vessel was needed.

The story was even accompanied by line drawings, one showing the small boy hoisting a keg over a bucket; another showing a woman drinking from the bucket, as the child looks on in dismay; and another of what would best be described in those times as a "bum," with the caption, "A Typical Tipper."

Again, there surely is some truth to this, but how much of it is reality and how much was propaganda can't be determined. However, this is more evidence of why anti-alcohol sentiment grew during the late 1800s and into the early 1900s, leading to first state-by-state and later national prohibition.

By 1905, a political party of sorts called the Fusion Party (which included both Democrats and Republicans) formed, intent on "right[ing] society's wrongs," as *The Encyclopedia of Louisville* put it. Its key targets were gambling, prostitution and saloons. Blue laws began going into effect, prohibiting drinking—and pretty much any other recreational activity—on Sundays in the city of Louisville. In fact, any place you could get a drink was simply closed on Sunday. Many states, including Indiana, still partially prohibit the sale of alcohol on Sundays.

I found one uncited news clipping in the men's room of a Louisville tavern called Big Al's Beeritaville during the writing of this book that relates this story from 1906: "Besides the saloons, all barber shops, billiard halls, bowling alleys, theatres, grocery stores and places of amusement are closed.

One practical joker even shuts the water off at a public water fountain, and hangs a sign on it that reads, 'Closed—it's sinful to drink on Sunday.'"

At first, brewers, worried that their livelihood was under fire, proposed a city ordinance that would close saloons at midnight, with the reasoning that most crime happened afterward. But the next year, statewide legislation gave counties the authority to vote themselves dry. This is when prohibition in Louisville began to take hold. By 1907, 95 of Kentucky's 119 counties were dry; by 1915, four years before Prohibition, that number had risen to 102. Jefferson County, where Louisville is located, remained defiantly wet.

It didn't last long. With the support of the Progressive Party, on January 14, 1918, Kentucky ratified the Eighteenth Amendment to the U.S. Constitution, banning the production and sale of alcohol, by a ninety-four to seventeen margin—just the third state to do so. The struggle continued, however, with a battle over whether state and federal laws should be in agreement; the prohibitionists garnered a temporary victory in November of that year that stopped the production of (but not the sale of) alcohol in Kentucky.

A newspaper account at the time, with the headline "Brewing Ends at Midnight," notes that brewers in Louisville that would be forced to shut down production included the aforementioned "big three" of Fall City Brewing Company, Frank Fehr Brewing Company and John F. Oertel Brewing Company, along with Phoenix Brewery, Menk's Brewery and John and Frank Walker's Clay Street Brewery.

At the time, the story notes, there were still about five months' worth of beer in reserve, the hope being that the tide would turn in favor of repeal of Prohibition prior to the forthcoming national July 1 deadline. It wasn't going to happen, however. In early 1919, a popular vote put Prohibition into effect in the entire state of Kentucky. In Jefferson County, more than two-thirds of the nearly thirty-six thousand voters cast their votes to keep the state wet, but in the end, it wasn't enough. Louisville, once a thriving brewing town in a bourbon state, was dry.

PROHIBITION AND THE DEATH OF BREWING (LEGALLY, ANYWAY)

On January 16, 1920, enforcement of Prohibition went into effect in Louisville; commercial brewing of beer in Louisville stopped, and thousands of gallons of beer were dumped. Twelve breweries were all that remained by this time, according to news accounts of the day. Guetig and Selle identify only six that remained in operation at the start of Prohibition in Kentucky: Oertel Brewing Company, Falls City, Fehr's, Menk's Lexington Street Brewery, Walter Brewing Company and William Palmer's Clifton Brewery. Southern Indiana Brewing Company was the only remaining brewery across the Ohio River.

Oertel's and Falls City managed to survive by downsizing and altering their business focus to ice and soft drinks; Falls City became the Falls City Ice & Beverage Company, while Southern Indiana Brewing became Southern Indiana Ice and Beverage Company. Meanwhile, the only way to get alcohol of any kind legally was to get a prescription for it—yes, many doctors would prescribe it for a variety of ailments, such as anemia, tuberculosis, pneumonia and high blood pressure. Unfortunately, such a prescription did not usually involve beer.

However, to say that Louisville stopped drinking beer would be an absolute, unmitigated lie. In fact, even some law officers would look the other way when it came to enforcing Prohibition, leaving it to federal officers, who were already spread thin. Bootlegging was rampant throughout the state, and many of the saloons and taverns either brewed beer or bought illegally made home brew. Speakeasies and illegal saloons known as "blind tigers"

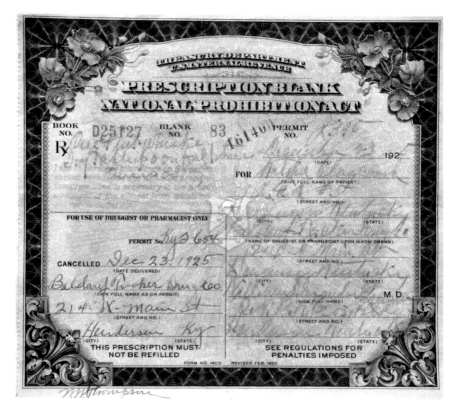

A prescription for alcohol from the Prohibition era. *Paul Young Collection; Jeff Mackey photo.*

thrived, and hundreds of gallons of illegal whiskey came to Louisville from Chicago every week by the mid-1920s. Famed Chicago gangster Al Capone spent many evenings at the Seelbach Hotel. People made booze in their bathtubs and carried alcohol in hip flasks.

The Encyclopedia of Louisville noted that one establishment that was well known for having alcohol on hand was Cunningham's downtown at Fifth and Breckinridge, and it was not raided by local law enforcement, presumably because it was owned by a former city police captain, James N. Cunningham. Cunningham's still operates today, on Fourth Street.

Most beer-loving Louisvillians, rather than give up their favorite beverage, simply became home brewers themselves. My father has a clay crock that he said his grandfather used to brew beer during Prohibition— many families in Louisville have such artifacts, in fact. It was just part of life during Prohibition.

Many of the taverns around town were raided, however, when the federal enforcers would take action. John Taphorn, owner of the aforementioned Taphorn's saloon, was raided multiple times and was once arrested for selling beer to soldiers.

A citywide raid in July 1922 not only involved the seemingly impervious Cunningham's but also Taphorn's and a number of other businesses and residences. Then chief prohibition officer U.G. McFarland and his men swept into a crowded Cunningham's, but it was not reported in the newspapers exactly how much beer and liquor were seized. Meanwhile, across town, police raided a soft drink stand owned by William A. Reardon in Portland and found a still and a small brewing operation in Reardon's home. Others to be raided that day included a soft drink stand on East Chestnut Street, a small bar in the Victoria Hotel and a roadhouse on Dixie Highway.

While "near beer"—beer that was almost completely stripped of its alcohol content—was available around town, it simply wasn't what Louisville wanted (although it did help some of the breweries continue operating for a time). Near beer sold well at first, but home brewing and bootlegging effectively killed it.

Germantown resident George Hauck was born in 1920 and has memories of Prohibition and near beer. "When I was a kid, there was a saloon at corner of Sixth and Market called Quino's," he said. "When we went into town, we would always stop at Quino's, and you could get a nickel glass of [near] beer or a dime glass of beer. I would get a nickel glass of beer, and we would always bring home six Swiss cheese sandwiches, which were fifteen cents. And they had that good mustard."

While Hauck, who still owns and lives at the grocery store that his mother opened in Germantown in 1912, said that he can't today recall the taste of the near beer, he insisted, "I'm sure it made that Swiss cheese sandwich taste better."

The archival book *Prohibiting Intoxicating Beverages: Hearings Before the Subcommittee of the Committee on the Judiciary United States Senate*, published in 1919, contains some fantastic passages about Prohibition and its pros and cons, some of which I must share in this book. These hearings date to June 1919.

The subcommittee included Thomas Sterling (South Dakota), Albert B. Fall (New Mexico), George W. Norris (Nebraska), Lee S. Overman (North Carolina), Thomas J. Walsh (Montana) and William H. King (Utah). In these transcripts, they debate with a Mr. Samuel Untermeyer, a New York lawyer who argued against Prohibition and, at least in this transcript, the specific

A crock used by the author's great-grandfather to brew beer during Prohibition. *Kevin Gibson photo.*

ways it would work related to beer, as well as how far Congress could go in enforcing the abolishment of its sale.

Some of the dialogue is downright ridiculous, especially as it pertains to these men's lack of familiarity—or feigned lack of familiarity—with the beverages they are discussing. And you will see that even near beer nearly didn't sneak past Prohibition. Here is a portion of the hearing transcript:

Senator Sterling: Might not a court say even then that in order to accomplish the end in view, to prohibit the sale of intoxicating liquors, Congress adopted that as a means to prohibit the sale of real beer, without reference to whether a particular beer or drink contained any percentage of alcohol or not?

Mr. Untermeyer: I do not think so.

Senator Sterling: Because under the guise of beer, under the guise of it's being a non-intoxicating beer, real beer might be sold under the claim that it was not intoxicating.

Mr. Untermeyer: You might prohibit, as I said, the sale of soda water or anything you wish under that pretext. No beverage business and nothing eatable would be safe.

Senator Sterling: That is reduction ad absurdum.

Mr. Untermeyer: Why, Senator Sterling, I do not see it that way. I may be obtuse. Why should not Congress prohibit the sale of ginger ale? You can put more whiskey in ginger ale than you can in beer without its being discoverable to the eye.

Senator Sterling: I will tell you why: Because that is not a means readily adaptable to the legitimate end in view.

Mr. Untermeyer: Fifty times more adaptable than beer.

Senator Walsh: Let me remark that I am not over familiar with these beverages.

Mr. Untermeyer: I do not drink them myself. I have never drunk a quart of whiskey or beer in my life.

Senator Walsh: I am told there is a popular drink on the market that does not contain any alcohol whatever but looks like beer. It foams like beer, it smells like beer, and you put it on the counter alongside a glass of beer, of ordinary alcohol beer, and you can not tell the difference between them, and they go so far as to say that if you drink a glass or two glasses you can not tell the difference in the taste.

Mr. Untermeyer: It contains all the ingredients of beer.

Senator Walsh: But no alcohol.

Mr. Untermeyer: The alcohol has been extracted, but the malt and hops are there.

Senator Walsh: Now, in the effort to enforce a prohibition act it has been discovered that somebody sets up an establishment for the sale of this particular kind of drink.

Mr. Untermeyer: Bevo, I think they call it.

Senator Walsh: Bevo. But it is disclosed that he has a stock of real beer behind his counter; and the right man comes in and asks for a glass of Bevo, of course giving the high sign, and the real beer is passed out over the counter to him, and thus the law is evaded. Now, under the circumstances, could we pass a law prohibiting the sale of both?

A Depression-era Falls City soda bottle. *Paul Young Collection; Jeff Mackey photo.*

Untermeyer responds "emphatically no," and adds, "Suppose people color plain water with a harmless coloring so that it looks like beer. Do you mean to say that under a constitutional provision preventing manufacture of intoxicating liquid you can stop the sale of that?"

Walsh says that yes, he believes Congress can do that, to which Untermeyer says, "What about sarsparilla and ginger ale?" From there, the conversation just gets even more ridiculous. Our great-grandparents' hard-earned tax dollars at work, it would seem.

Prohibition, it was quickly realized, was doomed to be a failed experiment. It is credited for decreasing the consumption of alcohol and the associated health problems (at least temporarily), but while fewer people drank, that many more turned to crime. Law enforcement was flouted. Basically, Prohibition turned many regular people into criminals and turned many established criminals into rich men. Talk of repealing the amendment began during the 1920s, and it was probably delayed only as a result of the stock market crash of 1929.

The Encyclopedia of Louisville quotes Ernest Rowe, who was charged with enforcing Prohibition in Kentucky, as saying in 1930, "It seems to be more or less the idea in Kentucky, as elsewhere in the nation, that where a person has a little home-brew cider or wine in his possesion, for his own use, he should be left alone."

He didn't mention beer, but we all know that it was included in the sentiment. On March 22, 1933, President Franklin Roosevelt signed an amendment to the Volstead Act; the Cullen-Harrison Act permitted the manufacture and sale of beer with a maximum ABV content of 3.2 percent. On April 4 of that year, Falls City filed a lawsuit against the Louisville & Nashville Railroad in Jefferson County Circuit Court for refusing to provide shipping for a batch of the new beer. It was believed to be the first of its kind in the nation and was a first strike in ultimate repeal.

Finally, on December 5, 1933, Prohibition was repealed, resulting in nationwide celebration, much of it involving beer. Louisville was right there with the rest of the country, with several breweries cranking back up and beer consumption resuming in earnest. Even more than eighty years later, Repeal Day is celebrated in Louisville, just like in most cities. Breweries and other watering holes around the city have Repeal Day parties that feature 1933-era beer prices, food of the day and sometimes even requiring a password to get in, much like at Prohibition speakeasies.

I earlier mentioned the big three of Louisville brewing: Oertel Brewing Company, Fehr's and Falls City. Since their stories span the rise of brewing

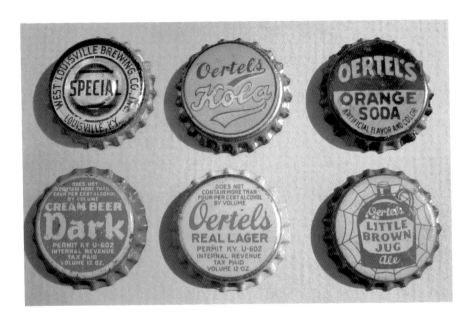

A collection of bottle caps from Oertel Brewing Company; some of these are soda caps from the Prohibition era. *David Timmer Collection.*

in Louisville, through Prohibition and into the final stages of Louisville brewing's initial history, next we'll get to know the stories of these well-known breweries that still remain close to the hearts of Louisville beer drinkers.

OERTEL BREWING COMPANY

While John F. Oertel didn't purchase his brewery and famously open it until 1892 (or did he?), the operation actually began in 1865 under the direction of a man named Franz Rettig. Rettig would sell it just three years into his proprietorship, and it would, in turn, be sold again in 1873, to brothers John and Charles Hartmetz, who already were operating a brewery and saloon a few miles away at Main and Wenzel, not far from Woodland Garden.

The Hartmetz family retained the brewery, even through Charles Hartmetz's death in 1887, with experienced brewer Oertel at the helm in partnership with Charles's widow, Magdalena. Interestingly, it was the Hartmetz brothers who launched what would later became the Evansville Brewing Company, which brewed Sterling beer (which became one of Louisville's favorite beers later in the 1960s). Some reports say that the brothers flipped a coin to see which one would move to Evansville, and that the honor went to John, leaving Charles in Louisville to attend to business.

The Louisville brewery, located at 1400–04 Story Avenue, according to legend, became Oertel's business alone in 1892 after he bought out Magdalena, but he operated for a time under the name Butchertown Brewery, obviously owing to its location in the city's Butchertown neighborhood. The bottling shop still stands there and is now a storefront.

Interestingly, however, the purchase of the brewery was in play well before the generally accepted year of 1892—at least according to a legal notice in the *Courier-Journal* that appeared on May 4, 1891, announcing the sale. "The

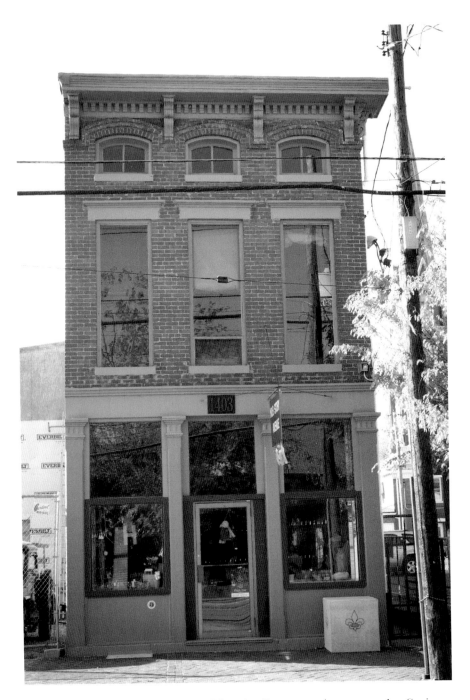

The last remaining building from Oertel Brewing Company as it appears today. *Cassie Bays photo.*

firm of Hartmetz & Oertel has this day dissolved by mutual consent," the announcement reads, with "John F. Oertel continuing the business and will serve his customers as well, if not better, than heretofore." Both Magdalena's and Oertel's names appear beneath the announcement.

Years later, the signature beer produced by the Oertel Brewing Company would be called Oertel's '92, a tribute to the year Oertel's officially began in Louisville. But it was early in 1891 when that changeover actually happened, or at least began to happen. (To think, it could have been called Oertel's '91. Maybe it just didn't roll off the tongue as well.)

Oertel, a Bavarian immigrant, quickly expanded the brewery and took steps to improve the beer, and by 1903, a new brewing facility was in place capable of brewing seventy-five thousand barrels of beer annually. While at the time Oertel made only common beer, the business was later incorporated as Oertel Brewery. It began cranking out a variety of styles, including an Old English Stock Ale.

Unfortunately, Oertel Brewery's rise was nearly snuffed out by a massive fire in 1908. Undeterred, Oertel and partners, William Rueff and Louis Bauer, pressed on, contract-brewing Oertel's beer through Phoenix Brewery while a new brewery—reportedly costing $75,000, according to records of the time—was being built.

When operations began once again in June 1909 after nearly a year of brewing the beer at other breweries, Oertel Brewery added a pale ale to its roster. Contract brewing with Phoenix continued, but by 1913, the rebuilt brewery had reached capacity, later adding a beer called Real Lager and also adding the bottling operation.

Unfortunately, the thriving brewery wilted under the heavy shadow of impending Prohibition; in 1919, Oertel Brewery filed for bankruptcy and was bought back by Oertel himself for $68,000—a bold move, considering the circumstances. Who buys a sagging brewery on the eve of nationwide Prohibition? John F. Oertel, that's who. He quickly turned the brewery into a maker of near beer, root beer, ginger ale and other non-alcoholic drinks and dug in his heels. Unfortunately, he would never see his company brew another beer—Oertel died in 1929.

Son John F. Oertel Jr. took over the company and rode out Prohibition; it was after the repeal that Oertel Brewery really began to thrive. According to various records, beginning in 1934 or thereabouts, Oertel's was producing Oertel's Real Lager, Oertel's Pilsner Beer, Oertel's Bock, Oertel's Cream Ale and Little Brown Jug Ale.

But that era also saw the launch of the aforementioned product that would become a favorite in Louisville for decades to come: Oertel's '92. In

fact, Oertel's '92 would become synonymous with the brewery and its legacy. It was a pale lager that no doubt was a crisp, easy-to-drink beer, based on its widespread popularity in the city. This was a time when the enthusiasm for beer in Louisville was thriving, even if it wasn't quite as strong as it had been in the late 1800s. The big three breweries sponsored everything from sports teams to events, parades and radio and television broadcasts, and every Louisvillian had his or her favorite.

Pee Wee King, a famous country/bluegrass musician from Louisville, was one who starred in a TV show sponsored by Oertel's. King was clearly a fan, based on a quote from Wade H. Hall's biography on King titled *Hell-Bent for Music: The Life of Pee Wee King*: "[Oertel's] sold more beer than the others combined," Hall quoted King as saying. "Oertel's was the beer of choice in Louisville." It didn't hurt, I'm sure, that Oertel Brewery sponsored King's television show. Still, it's an illustration of how deeply the loyalty ran to most Louisvillians' beer of choice, and Oertel's had its share of loyal drinkers. My paternal grandfather played guitar on a radio show that, if photos are an indication, was sponsored, in part, by Falls City. I bet I know what he was drinking back then.

Hauck, the Germantown grocery store owner we heard from previously, said that when he got out of the navy in 1946, he began carrying bottled beer in his store. "I'd say at that time [the big three] sold 90 percent of the beer sold in Louisville," he said. The reason for this loyalty was that almost everyone in the city knew or was related to someone who worked or had worked at one of the major breweries. Hauck's father worked at Fehr's, while he had two uncles who worked at Falls City and another who worked at Oertel's.

"Budweiser had a distributor in Louisville on First Street," Hauck recalled. "I think I got one case of Budweiser bottles a week. [The local beer] didn't only sell better—that's just the way it used to be. The only reason somebody came in and bought a Budweiser was they were usually out of state, and Budweiser was the only brand of beer they knew about. Someone from St. Louis isn't going to come in and say, 'Give me an Oertel's beer.'"

Oertel's advertised with the best of them, running in the 1940s with an advertising slogan, "Cheer up with Oertel's '92." An ad in the *Middlesboro Daily News* from August 1940 read:

Take an empty glass. Almost any empty glass will do. Fill it to the brim with foaming, sparkling Oertels '92 Beer. And—presto! Your glass becomes radiant, brilliant…a thing of sparkling, amber beauty…proudly wearing a crown of pure white! Your glass now filled with Oertels '92 beer seems

An Oertel's '92 coaster. *Paul Young Collection; Jeff Mackey photo.*

to glow with a friendly cheerfulness! Hold it up to the light, and see. It does—doesn't it? And it should. For a glass filed with Oertels '92 beer…is the accepted symbol of good cheer. More than a million folks regard it as such. It has a friendly way of bringing them pleasure…and refreshment…and good cheer. Even as it will bring to you…the next time you have an empty glass…fill it to the brim, with Oertels '92.

Despite the snappy ad copy, by the 1950s Budweiser and other emerging national brands, armed with ever-increasing advertising budgets and a legion of refrigerated trucks and train cars, were beginning to cut into the sales of Oertel beer, which, at its height, was being sold in multiple surrounding states.

Jimmy Dickens performs during the mid-1950s at what is now the defunct Louisville Gardens, with an Oertel's '92 logo proudly displayed behind the stage. *Bob Mitchell photo.*

In 1961, John F. Oertel Jr. died. Just three years later, the company was acquired by Brown Forman, a well-known Louisville producer of spirits, for a reported $600,000; it was confident it could save the sagging brand. But Oertel's was experiencing the same fate as so many other local and regional breweries. Guetig and Selle asserted that in 1934, just after the repeal of Prohibition, 756 breweries reopened in America. But by 1965, only 182 remained.

While the introduction of a new brand—Oertel's Real Draft Beer—helped buoy the company for a time in the mid-1960s, leading to the release of Thorobred Malt Liquor and Oertel's Cream Lager, the Louisville brewery simply couldn't compete with Anheuser-Busch and Miller. Faced with the need to spend a large amount of money to update the aging brewery operation, and after finding no buyer for the brewery, Brown Forman closed Oertel's on December 1, 1967.

The brand was nearly revived in the early 1990s when a group of local investors pulled in former brewmaster Friedrich W. Finger Jr.—who held the title from 1939 until 1965—to create a new recipe; the goal was to open a

microbrewery in the old Oertel's bottling building at Webster and Story, but the venture ultimately failed. A story in the *Courier-Journal* from 1993 noted that the revived brand was sold in the city for a time as a contract brew with the Joseph Huber Brewing Company of Monroe, Wisconsin, with Finger as the head brewer.

The old bottle shop was about to become not just a brewery but also a restaurant and entertainment complex, and had it worked, it would have been one of only three breweries in the city. A dozen Louisville bars briefly had the new Oertel's beer on tap, and the anticipation of having it in cans and bottles was high.

One of the "new" Oertel's investors, David Barhorst, was quoted in a *Courier-Journal* article as saying, "I get calls every week from some distributor in Eastern Kentucky or the Southern Region...They call up expecting the beer."

"I'm no beer expert," said Bristol Bar & Grille owner Doug Gossman at the time, "but I thought it had a good flavor to it. It has a little more flavor than your typical American beers do."

Ultimately, a group of investors that was supposed to operate the restaurant side of the new Oertel's pulled out, and the planned "advertising blitz" and brewery build-out never happened. But owner Jan Schnur kept the trademark active in the hopes of one day releasing Oertel's beer in Louisville again. Now seventy-five, Schnur in early 2014 conferred with Selle and Leah Dienes at Apocalypse Brew Works to brew an Oertel's beer. The recipe was based on Oertel brewing logs that Schnur owns. There is talk that other Oertel recipes could be brewed. "Louisville loves it," Schnur told me in the spring of 2014.

Called Oertel's 1912, the beer drew media attention and sold well at the small brewery, which is just blocks from where Oertel's originally stood. As of this writing, Oertel's beer again has a future.

FRANK FEHR BREWERY

Frank Fehr founded his brewery in 1872 on Green Street (now known as Liberty Street) between Preston and Jackson. Chances are that he had no idea that his company would become so successful that the Fehr's brand would be synonymous with beer for nearly one hundred years and that his family would become one of Louisville's best known.

Originally known as the William Tell Brewery, Fehr and Otto Brohm took it over and operated it jointly for four years as Fehr & Brohm, until disaster struck. "[Fehr's] skill, energy and reputation soon made this enterprise a great success," according to *The History of Kentucky* by Zachariah Frederick Smith, "until a fire in 1876 destroyed the labor of years. With the courage that characterized his life, Fehr bought the site of the old owner, borrowed money, and began again."

The year of the fire was actually 1877, according to newspaper accounts—in fact, the fire destroyed the brewery, at that time known as City Brewery, on September 12, 1877, as related by a newspaper report of the incident. The "very warm and, for a time, very defiant" fire broke out sometime after noon, as employees ate lunch. Manager Max Lorsch called the fired department, which responded at 12:54 p.m.

According to the *Courier-Journal* story about the fire, the brewery was divided into three parts: a stable, near Preston Street; the brewery operation and malt house in the center; and an icehouse, where beer was lagered. As firefighters battled the blaze "in very good style," a strong wind blew the fire east, "rendering the ice-house anything but an ice-house." Its roof caught

fire, and while the blaze was brought under control about an hour after it started, the damage was devastating. Fehr himself had been home sick when it broke out; that he decided to buy the site and rebuild is a testament to his determination.

Fehr, a thin man with a high widow's peak and a Van Dyke beard, was born in Alsace, France, in 1841. He immigrated to Baltimore as a young man in 1862. He later worked in Chicago and Cincinnati before coming to Madison, Indiana, to run the Madison Brewing Company. By 1868, he was managing Phoenix Brewery before teaming up with Brohm. His business savvy was well recognized in Louisville, and the husband and father of three quickly became one of Louisville's true beer barons.

Records indicate that Fehr brewed 2,500 barrels of beer during the first year of Fehr & Brohm; by 1880, after taking over the brewery and completely rebuilding it, Frank Fehr Brewing Company was brewing 30,000 barrels. By 1890, the annual number had increased to 75,000 barrels, and Fehr's beer was recognized nationally.

The man put an incredible amount of capital into his brewing operation; very early in his ownership, he purchased a De La Vergne ice machine, a state-of-the-art machine of its day, at a cost of $350,000—a staggering amount given the period. The machine was one of the largest in the South and was a huge boon to the city, reportedly dropping the price of a pound of ice from one dollar to one quarter. By the early 1890s, Fehr had three such machines, according to a newspaper profile of the brewery. Meanwhile, the capacity of the brewery was believed to have grown to somewhere between 150,000 and 250,000 barrels annually.

Unfortunately, he would not live to see his brewery prosper for long, as he died on the morning of March 15, 1891. In his obituary, it was noted, "Mr. Fehr was a wealthy and enterprising citizen, and was noted for his great liberality and charity."

His brewery fell to the management of John F. Kellner, a "prince of brewers," according to the *Courier-Journal*'s "Beer Barons" story. He was described as a large, two-hundred-pound man with a "distinguished presence." He was believed to have the full confidence of the Fehr family until the reins were handed to Fehr's son, Frank Fehr Jr., in 1898. By 1900, Fehr's was far and away the largest brewery in the city, after acquiring a bottling plant and several adjacent lots as part of ongoing expansion.

Fehr's made a lager beer, malt tonic and the popular Frank Fehr X-L (which stood for "extra lager"), no doubt a stronger, darker beer than the regular stuff, and the company's beers were award-winners in the late

An unidentified woman enjoys a snack and a Frank Fehr beer, circa 1910. *Marvin Gardner Collection.*

1800s. The brewery also released beers called Ambrosia and XXXX Stout, among others.

Fehr Jr., who would later be known as Colonel Frank Fehr, followed in his father's footsteps not just as a master brewer but also as a respected, charitable friend of the city. In the book *A History of Kentucky and Kentuckians*, by E. Polk Johnson, Fehr Jr. is described as "well upholding the high prestige of the honored name which he bears"; it was also noted that his heart "was so attuned to human sympathies that he was ever ready to lend his aid in the support of worthy charities and benevolences."

Fehr Jr. was a respected businessman in the mold of his father and made his own mark, first playing center on Notre Dame's first-ever football team and later taking up the brewing mantle. However, he was also an imposing figure and an aggressive businessman, and part of the reason Frank Fehr

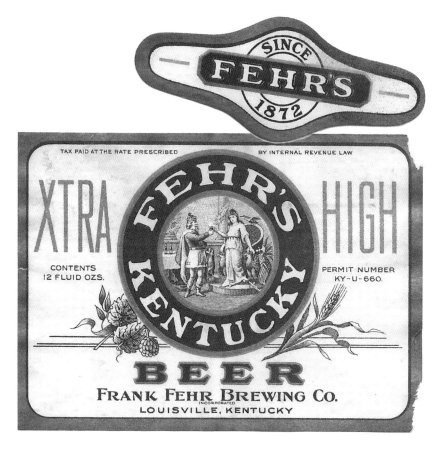

Fehr's Kentucky beer label. *Marvin Gardner Collection.*

Brewery was so successful was the aggressive way its leadership set out to seize control of the saloons around town.

Tragedy struck the Fehr family in 1909, when the daughter of Fehr's cousin Frederick Kellner went missing. Alma Kellner, just eight years old, disappeared after leaving home to go to a nearby church to pray. For months, the mystery went unsolved, with most assuming that Kellner had been kidnapped. This led to false ransom demands across the country, false sightings suggesting that the girl was kidnapped by gypsies and false hope; Fehr himself took charge of investigating and negotiating.

None of the leads panned out, however, and much to the family's dismay, Alma's dismembered body was found in the church on May 31, 1910—she had been brutally murdered, partially burned and left in a cellar; she was

only found when the cellar flooded. The discovery sent a shockwave across Louisville, which had followed Alma's disappearance closely.

Joseph Wendling, who had been a janitor at the church at the time "Little Alma Kellner," as the press dubbed her, disappeared, was later tracked by a tenacious Louisville detective through Texas and all the way to San Francisco, tried and convicted of her murder. He spent nearly two and a half decades in prison before being paroled and reportedly maintained his innocence until his death. Alma's murder was later loosely connected to a priest named Hans Schmidt, who was in Louisville at the time and who also was later convicted of murdering and dismembering his secret wife. He was dubbed the "Killer Priest" and was later suspected of several other killings, but no hard evidence exists to suggest that he murdered Alma.

The case was a lesser version of the "Lindbergh Baby" kidnapping, being reported not just nationally but also internationally and becoming a well-known mystery that transfixed much of the country while police and the Fehr family frantically tried to locate Alma. In fact, while researching this book, I became nearly obsessed with the story, unearthing detail after detail that, frankly, would add up to make one hell of a movie if a film producer ever took the notion. The tragic story brought me to tears on more than one occasion; Alma's body is buried at St. Louis Cemetery on Barret Avenue in Louisville, and I was moved to visit her and place a flower on her grave.

Happier days were ahead for the Fehr family, however; beer sales thrived for the next few years, until the inevitable fall-off in the years leading up to Prohibition. Much like Oertel Brewery, Fehr's continued operations after Prohibition began, making near beer and soda, providing ice and at one point even running the aforementioned mushroom-growing operation in what had previously been the cellars beneath Phoenix Brewery. A fire forced Fehr's to close for a time during Prohibition, but with national repeal, brewing resumed in September 1933.

Much like Oertel's brewery, the reopened brewery began to thrive. Armed with a number of beer styles—including Fehr's Kentucky Beer, Mello Beer, Fehr's Bock and the signature Fehr's Beer—the brewery picked up where it left off as one of the kingpins of Louisville brewing. In fact, it was one of the largest brewing operations in the country, including being the largest in the South. Fehr's again was king of beers, with Colonel Frank Fehr still at the helm.

Fehr's X-L also made its return and was a popular favorite of its day. A 1937 advertisement provides a glowing description of the beer: "Everybody likes a winner. All over the south, Fehr's X-L (Extra Lager) is capturing

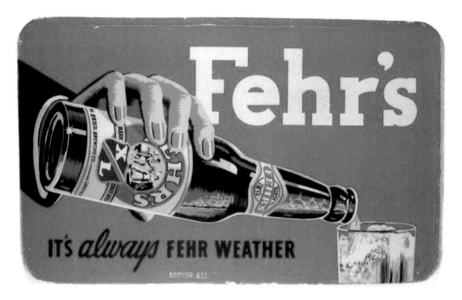

Fehr's X-L sign, circa 1950s. *Jeff Faith Collection.*

thousands of new friends for its winning qualities. They like its fine, natural color, brilliant sparkle, and robust 'body.' Best of all they enjoy its keen, zesty flavor, a dry refreshing taste no other beer can match. And here's why X-L is so satisfying. It's pure grain *kruezened* beer, made entirely from nature's own ingredients, golden barley-malt, rice, and hops, with no artificial elements added. And it's always leisurely aged, never hurried. That's all there is to it—plus 65 years of knowing how." I kind of wish I had a Fehr's X-L right now after reading that, but I digress.

The brewery flourished through World War II, and by 1949, production had reached its apex. Soon, competition from Milwaukee and St. Louis—as well as the rise of Sterling Beer, from Evansville Brewing Company—caused a decline in sales. Guetig and Selle wrote, in fact, that between 1949 and 1957, the drop in total sales was nearly 70 percent.

Competition was one problem, but another was the introduction of Fehr's Liquid Gold, a beer advertised as being purer because it was more highly filtered. Each bottle came with a vial of "gurk"—the stuff that supposedly was filtered out of the beer, making it so much clearer. It was an interesting gimmick, to be sure, and it sold well at first. The result, of course, was that Fehr's other beers were suddenly cast as being impure, causing a consumer backlash of sorts. It was almost like the failed "New Coke" experiment of the 1980s.

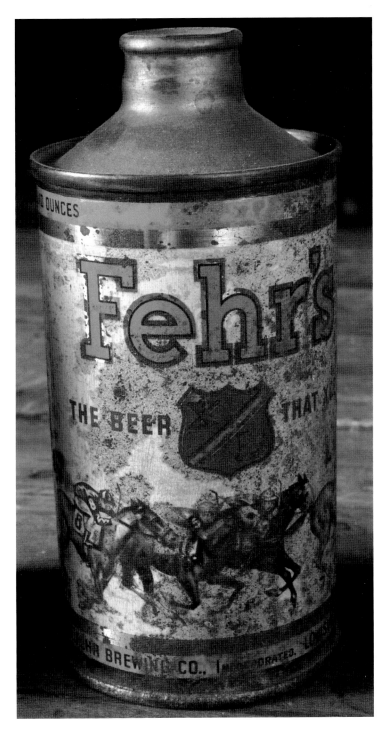

An early Fehr's X-L can depicting horse racing. *Private collection; Rick Evans photo.*

Soon, the Fehr house was in disarray. A battle for control of the company emerged, as Colonel Fehr was succeeded as president by nephew Fehr Kremer in 1953. This began a battle for control between Kremer and Frank Fehr III; by 1957, the company was bleeding money and filing for Chapter X bankruptcy. A newly reorganized Fehr's had dropped Liquid Gold by 1959 and was selling Fehr's Pasteurized Draft Beer, Fehr's X-L and Kentucky Malt Liquor. Sales increased, but the company floundered anyway. In 1964, Fehr's closed its doors.

The last seven thousand barrels of beer were dumped into the sewers in February 1964 to avoid paying nine dollars per barrel in federal tax on the beer, with the Associated Press reporting that the operation took place over the course of several days. It was the equivalent of 2.25 million bottles of beer going into the city's sewer system, which is why it was done so systematically.

"If we dump it too fast," a company official was reported as saying in a court document, "Fehr Avenue will become a mountain of foam."

"What a day for sewer mice!" commented one writer.

A senior citizens housing development currently stands on the site of the old brewery.

Schoenling Brewing Company of Cincinnati purchased the recipes and rights to the Fehr's name; it continued to make Fehr's X-L for a time. That brewery closed in 1987 and has since reopened.

Fehr's continues to be a beloved brand. Louisville native Gar Davis remembers that his aunt worked for Fehr's in the early 1960s. She was given two free cases of beer per month, but since she didn't like beer, the cases of Fehr's always went to Davis's dad. Davis can remember visiting his aunt, Edna Blankenbaker Wilcox, at work. "I also remember that she had bought her first new car, a 1960 Ford Falcon," Davis said, "and shortly thereafter it was driven over by a beer truck at work and crushed."

Another Louisville native with Fehr's memories is Paul Garcia, whose father built a fireplace in the family home from bricks collected from the torn-down Fehr's brewery. A loyal Fehr's drinker, Mr. Garcia took Paul, then five, and his seven-year-old sister to "explore the ruins" of the old plant just before they were about to move from Louisville to southern Indiana. There, his father collected the brick to build the fireplace, which is still intact today. "The west side of the building had been removed, and one could still see the bottling line with cases ready to be filled," Paul said. "I managed to get two empty cases and fill them with unused bottle caps. I had about two weeks of playing with my 'treasure' before my mother disposed of them."

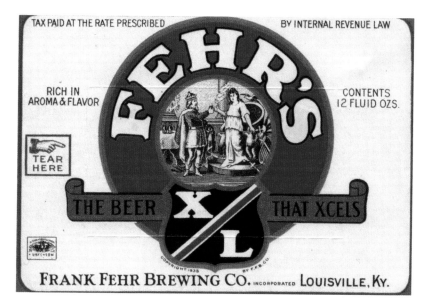

A Fehr's X-L label. *Author's collection.*

An array of colorful beers at Bank Street Brewhouse. *Rick Evans photo.*

Left: New Albanian Brewing Company founder Roger Baylor. *Cassie Bays photo.*

Below: The original Bluegrass Brewing Company as it looks today. *Jeff Mackey photo.*

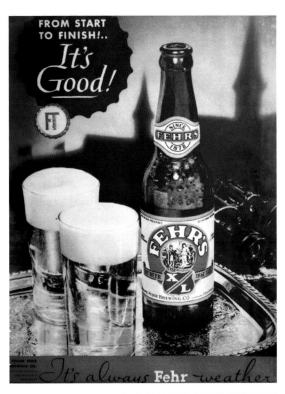

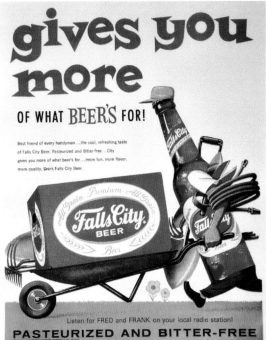

Top: A Fehr's X-L ad, circa 1950s. *New Albanian Collection.*

Left: A Falls City Beer ad, circa 1950s or '60s. *Paul Young Collection.*

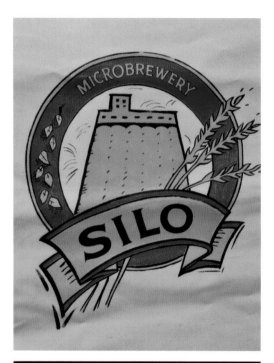

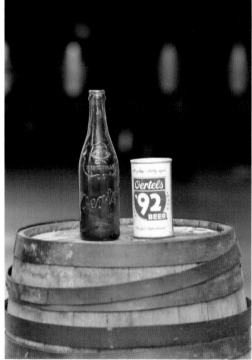

Top: A rare original Silo Microbrewery banner. *Paul Young Collection.*

Left: A vintage Oertel's bottle and can. *Paul Young Collection; Jeff Mackey photo.*

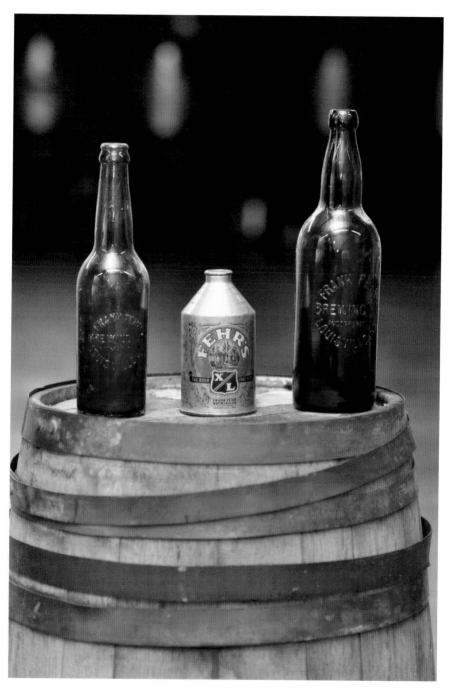

A collection of vintage Frank Fehr bottles and can. *Paul Young Collection; Jeff Mackey photo.*

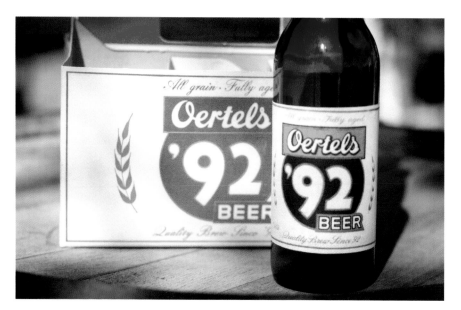

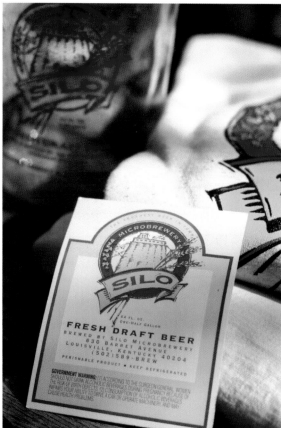

Above: An Oertel's '92 bottle and six-pack container. *Author's collection; Cassie Bays photo.*

Left: Original Silo breweriana. *Eileen Martin Collection; Cassie Bays photo.*

Above: Zach Barnes, Vince
Cain and Matt Fuller of
Great Flood Brewing. *David
Mackey photo.*

Left: A pair of Browning's
pint glasses. *Author's and
Eileen Martin Collections; Cassie
Bays photo.*

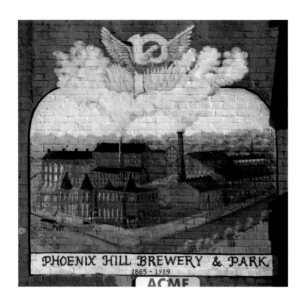

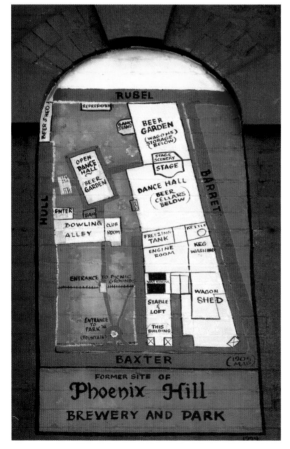

Top: A mural depicting Phoenix Brewery, located on the last remaining original brewery complex building. *Cassie Bays photo.*

Left: A mural depicting the layout of Phoenix Hill Park, located on the last remaining original brewery complex building. *Cassie Bays photo.*

Left: Pat Hagan of Bluegrass Brewing Company. *Cassie Bays photo.*

Below: A vintage wooden Falls City beer case. *Dave Easterling's Falls City Collection; Rick Evans photo.*

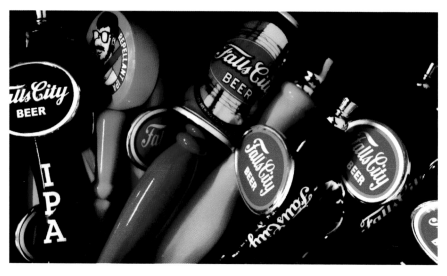

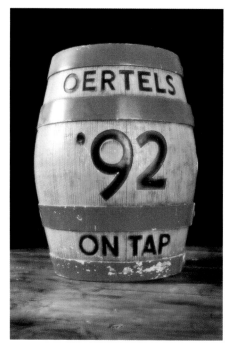

Top: A collection of Falls City tap handles. *Dave Easterling's Falls City Collection; Rick Evans photo.*

Middle: A wall mural at Bank Street Brewhouse. *Rick Evans photo.*

Left: An Oertel's '92 promotional item. *Private collection; Rick Evans photo.*

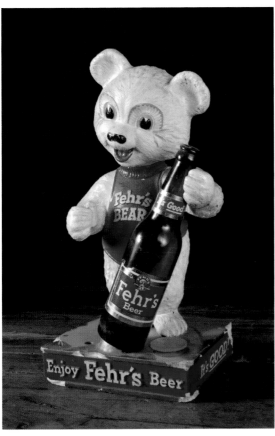

Left: A Fehr's promotional item. *Private collection; Rick Evans photo.*

Below: A vintage Fehr's six-pack, circa 1950s. *Private collection; Rick Evans photo.*

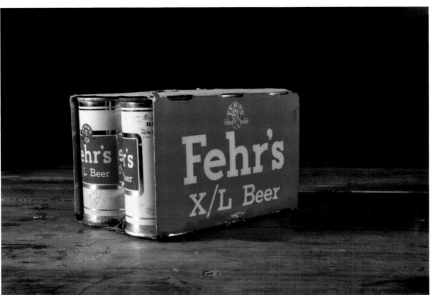

Top: Vintage Fehr's bottles. *Private collection; Rick Evans photo.*

Left: Pipkin Brewing bottles. *Private collection; Rick Evans photo.*

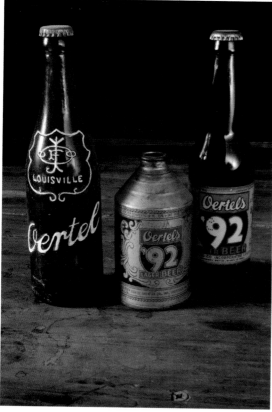

Above: Vintage Fehr's containers. *Private collection; Rick Evans photo.*

Left: Vintage Oertel's containers. *Private collection; Rick Evans photo.*

Top: The original Bluegrass Brewing Company sign, now located at BBC's downtown taproom and beer museum. *Rick Evans photo.*

Left: A vintage Falls City sign. The bottle man was in a popular TV commercial in the 1960s. *Dave Easterling's Falls City Collection; Rick Evans photo.*

Opposite, top: A lucky lady endorsing Falls City in a vintage promo. *Dave Easterling's Falls City Collection; Rick Evans photo.*

Opposite, bottom: A Falls City beer sampler. *Rick Evans photo.*

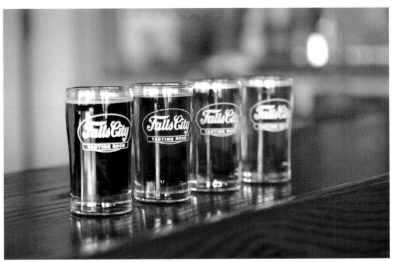

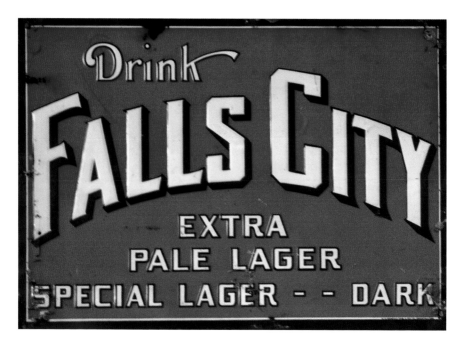

A vintage Falls City sign. *Dave Easterling's Falls City Collection; Rick Evans photo.*

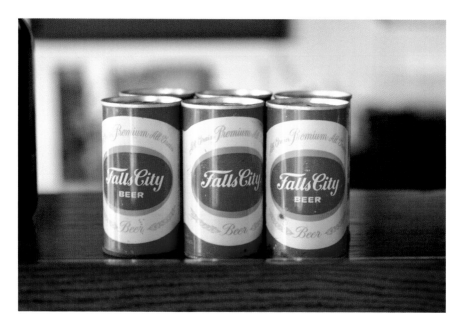

A vintage Falls City six-pack. *Dave Easterling's Falls City Collection; Rick Evans photo.*

Bluegrass Brewing Company, for a short time around 2000, featured a golden ale called Fehr's Darby Ale; then-brewmaster David Pierce said that the beer was based on an old Fehr's formula. It later became known as BBC Gold. As of this writing, Louisvillian Jeff Faith has acquired the brand, created several test batches of Fehr's X-L and was hoping to have Fehr's beer back on draft around town in 2014.

It is a happy occurrence. Like Oertel's, Fehr's lives on as a nostalgic favorite, and its breweriana remains highly collectible. Type Fehr's into eBay's search engine sometime, and you'll get an idea of just how mighty Fehr's once was. Like Oertel's, Fehr's beer is set to reemerge. Another classic Louisville brand that has come back to life is Falls City, which was the last remaining brewery in Louisville for many years.

FALLS CITY BREWING AND
LOUISVILLE BREWING'S LAST STAND

Falls City Brewing Company was the last brewery standing in Louisville following the closure of Oertel Brewery and Frank Fehr Brewing Company. It, too, has a rich history and is remembered today as one of Louisville's favorite beer makers.

Falls City was a latecomer, having been formed in 1905 by a collection of saloon owners and grocers who were in protest of the aforementioned Central Consumers Company alliance formed by the brewers that had essentially monopolized beer sales in the city. This group of businessmen combined forces and built a seventy-five-thousand-barrel brewery at Thirtieth Street and Broadway downtown, next to Southern Railroad.

It should be noted that a number of smaller operations brewed beer under the name Falls City well ahead of this brewery's launch; again, as breweries opened, closed, reopened and changed hands in the 1800s, a number of names came and went.

Otto Doerr, formerly of Schaefer-Mayer, was hired as brewmaster, and in November 1906, Falls City Beer was tapped for the first time in Louisville's saloons and taverns, starting a legacy that is still strong today.

By 1908, Falls City had added a bottling plant and was selling bottled beer across the city, as well as draft beers bearing interesting names such as Peerless, Salvator, Life Saver and Extra Pale. During the first years of its operation, deliveries were made with the customary horses and wagons. According to the Kentucky Digital Library, in 1911, Falls City bought a five-ton Morgan truck and a one-and-a-half-ton auto car, "and there was great

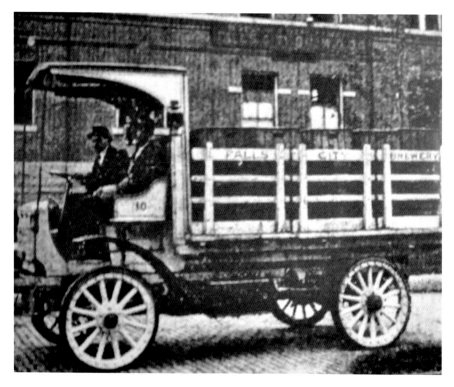

Undated pre-Prohibition photo of a Falls City delivery wagon. *Dave Easterling's Falls City Collection.*

rivalry amongst the drivers as to who would be chosen to drive these two new trucks."

While the brewery struggled at first, by 1912 it was making a profit, narrowly surviving a 1911 takeover bid by rival Central Consumers. In fact, a meeting on December 11, 1911, to discuss selling Falls City to its rival began in the afternoon and lasted until nearly midnight, with a number of heated debates ignited along the way. But the ultimate decision, at the urging of loyal stockholders, was to keep moving forward. Of course, this was a huge victory for Falls City, which had the original mission of competing against the monopoly.

The ensuing seven years were steady, but a lack of capital and continued competition with the Central Consumers Company provided obstacles to growth. Of course, you already know what happened in 1919—Prohibition forced the brewing operation to close, and the property was sold at auction to a man named George F. Korfhage for $61,000 just two weeks before

The author's grandfather, Harold Gibson (center), with his band sometime during the mid-1940s. Oertel's wasn't the only brewery sponsoring live music. *Courtesy of Ronald Gibson.*

national Prohibition was set to become law. Korfhage, along with some newly assembled investors, kept the facility running, producing near beer and soft drinks and selling ice under the name Falls City Ice and Beverage Company.

But perhaps surprisingly to all, the plucky little Falls City did not merely manage to stay afloat; it actually turned a profit during Prohibition. When the boilers were again fired up in late 1933, Falls City was primed and ready to start brewing beer for Louisville and beyond. The brewery found an eager audience. Following Prohibition, beers such as Hi-Bru, Falls City Ale, Falls City Bock, Falls City Extra Pale and Falls City Lager were being produced and sold across the city and the South.

Not unlike at Oertel, Korfhage's death in 1929 ensured that he would never see a beer brewed at the plant, but his leadership would see Falls City distribute its soft drink products regionally—it previously had sold only locally—paving the way for beer brewing later. It should be noted that after Korfhage's death, former Falls City president Theodore Evers was named

... for fun pick the **Popular** one
its **Bitter-free** taste
pleases everyone!
Pasteurized *Falls City* BEER

A vintage Falls City ad proclaiming "bitter free." (Note the horse racing tie-in.) *Paul Young Collection; Jeff Mackey photo.*

secretary and treasurer. At that time, a woman named Lillie G. Madden was named assistant secretary. She would go on to become a key player in the story of Falls City brewing. By the late 1940s and into 1950, Falls City was brewing 750,000 gallons of beer annually and distributing to Kentucky,

Indiana, Ohio, Tennessee, the Virginias and Illinois. It had become a dominant southern brewery.

In 1951, the death of longtime president John W. Bornwasser opened the door for Madden—known as "Miss Lillie"—to become president. By 1955, the Falls City plant was undergoing several major upgrades, including a new barrel kettle and faster bottling lines. At one point, it was the official beer of the Indianapolis 500, and it enjoyed popularity throughout the region.

But as the years went by, Anheuser-Busch, Miller Brewing, Schlitz and others were establishing their strangleholds on the brewing industry in the region and around the country. Falls City began to adapt its flavor as a way of keeping up, and this would gradually result in the beer being less and less flavorful as America began its swing toward corporate light beer.

Advertisements from the 1950s show this emerging trend. A Falls City ad from the *Kentucky New Era* in May 1956 promotes pasteurization of the beer, promising that it is "sparkling…light…refreshing," that it "always tastes the same" and that it was "bitter-free," bragging that "our process keeps hop's [*sic*] bitterness OUT…locks the right amount of taste-pleasing flavor IN."

By comparison, as recently as 1939, Falls City was describing its beer as "amber" and describing the flavor as "dry," with "mellow heartiness" and "perfect balance." That was Falls City Hi-Bru, and it clearly predates the "light" trend.

Creativity in brewing was dying under the weight of corporate homogenization. Meanwhile, Falls City was doing what it had to do in order to survive, which was to get creative. One offer in the 1950s was for a "Holiday Gift Pack," a way to give your friends and family the gift of bitter-free beer in a festive, holiday package at no extra charge—a package that they were just going to throw away. A 1962 ad in the *Kentucky New Era* is positioned as a personal classified ad and reads, "PARTNER WANTED: Man with cooler full of Falls City Beer and fishing rod wants to meet man with can opener and fishing rod. Object: Fishing trip. Fishermen agree that you can't buy better tasting beer than Falls City at any price."

Kenneth Schwartz, whom we met earlier, recalls the slow but sure decline following years of thriving under Madden, beginning with the brewery improvements in 1955. "They decided they wanted to put a new powerhouse in, and a new engine room," he said, peering through oval wire-frame glasses. "Those two boilers they put in were brand new. They put new equipment in the brewery part, too—tanks and stuff like that. They bought us a new fleet of trucks. One thing about them: when they made up their mind to do

something, they done it. And they didn't buy that stuff on time—they paid cash for it."

He recalled Madden as being very strict but very fair with her employees. "She was a smart woman," Schwartz said. "As far as I'm concerned, she's the one who built that brewery up to what it was." In later years, he said, employees could drink only in a certain part of the plant, and the limit was two. Schwartz said that he recalls a former co-worker who would go beyond that limit, and one day Madden walked in and caught him. "He said, 'I guess I'm fired?' and she said, 'You are so right.'"

But as the 1960s wore on, sales declined. Distribution and consumption of national brands were on the rise, and local loyalty was waning—well, for everyone but the brewery workers. "When I worked there, that's the only beer I drank," Schwartz said. "Even if I was at somebody's house and they offered me a beer, if it wasn't Falls City, I wouldn't drink it."

He came home from work one day to find a non–Falls City beer sitting on his kitchen table. "I said, 'What in the hell?' My wife said, 'What's the matter with you?' I said, 'Whose beer is that?' She said, 'It's your son's.'" He picked up the beer—"It was maybe a Bud or a Miller," he said—opened the door and slung the bottle out into the yard. "I said, 'Tell him there's his beer.'"

Schwartz said that it gradually became clear that the brewery was going downhill. Finally, a last-ditch scheme to save Falls City was hatched in 1977. It almost worked. Falls City persuaded famous beer drinker Billy Carter (brother to then president Jimmy Carter) to switch brands and endorse Falls City's specially brewed Billy Beer. That beer was released in September and was popular at first. Billy Carter himself came to Louisville, toured the Falls City plant and even made a visit to Check's Café in Germantown, where a picture of his visit still hangs. He was even quoted at a press conference during his visit as saying, "Who knows? Maybe I'll become the Colonel Sanders of beer." Maybe not.

"He come back there and shook my hand," Schwartz said. "I didn't think much of him." Still, the Billy Beer experiment nearly worked and showed a great leap of faith on the part of the struggling brewery—or possibly a last-ditch effort of desperation.

"The only way to survive is to be innovative," then Falls City president James F. Tate told the Associated Press, "and that's just what we've tried to do…When you go up against the big guys in this industry, you have a helluva job on your hands."

Tate said in that article that Miller and Anheuser-Busch were spending $100 million annually in television advertising and were "chasing us off

There are still a few original Falls City signs around town. *Cassie Bays photo.*

television" as a result. In addition, by that time, one of the two mega-brewers was sponsoring pretty much every major event in town. Falls City couldn't compete in its own market, let alone regionally or nationally.

While publicity fueled the first few months of sales, keeping Falls City in the black for 1977, a massive winter snowstorm immobilized the entire city of Louisville in January 1978 and brought sales and distribution to a near standstill in the process. By May, sales of Billy Beer were inching back up, but the end was near. Another problem was that the price point was higher than Bud and Miller, and people simply didn't want to pay it once the novelty wore off. Some of that price point had to do with Carter's royalties. "They paid him I don't know how many thousands of dollars just to put his name on the damn thing," Schwartz said. "It went over pretty good for a while. It went over well in these colleges because it was something different. Pretty soon, *boom*—it just petered."

Brewing in Louisville was dying a slow death; it was a national trend. A *Bowling Green Daily News* story from June 8, 1978, reported that just after Prohibition, between 1933 and 1935, some 750 breweries were in operation in the United States. At the time of Billy Beer, the number was down to 45.

Late in 1978, Falls City closed; newspapers around the country in November of that year ran a photo of a Reynolds Aluminum Recycling Plant in Louisville shoveling beer cans onto a conveyor belt. Falls City had sold 8.7 million Billy Beer cans to the plant in the shutdown, a sad symbol of the brewery's last stand. The plant was sold, the equipment was shipped out of the country and the buildings were demolished. The brands, including Falls City and the lesser-known Drummond Bros., were sold to the Heileman Brewing Company.

Schwartz, who said that he was the last hourly employee at Falls City, remembered his last two days on the job: "I left there one day, and [Tate] said, 'Tomorrow morning, Kenny, when you come in, shut the boiler down.' I said, 'All right.'" When he finished shutting down the last operating boiler, Schwartz walked around the plant one last time and said his goodbyes to a few of his co-workers. Then he got into his car and drove home, in search of a new way of life. And with that, the lights went out on brewing in Louisville. At least for a while.

LOUISVILLE BREWING ISN'T DEAD YET

True beer lovers no doubt took the rise of the Evil Beer Empires pretty hard. While most of America was busy not caring during the 1980s, there were still a few breweries here and there putting out good beer. Anchor Steam Brewing in California is an example—its products just weren't making it to Louisville. But the rise of California brewing in general was beginning to take hold. Of course, there was also that place called Europe.

Mark Twain is often quoted as saying, "When the end of the world comes, I want to be in Kentucky, because it's always twenty years behind the times." It's doubtful that Twain really said it—it just sounds like something he would have said, and there probably is some truth to it regardless. And so most people in Louisville drank Bud or Miller.

However, there were more than a few people in Louisville who were not only interested in good beer but also out to do something about the unsettling dearth of it. Home brewing was still going on with reckless abandon in garages and basements. Inevitably, when people would travel abroad and then return home to Louisville, they would bring with them a craving for the far more interesting beers they'd tasted in Germany, England or Belgium. (Okay, especially Belgium.) Nothing had really changed in Europe; good beer was still being brewed and consumed daily, oblivious to the cheap swill that was inexplicably being shoddily created and choked down in the United States at ballgames and backyard barbecues.

The enterprising beer lovers in Louisville would buy or adapt some crude brewing equipment and attempt to re-create these complex and interesting

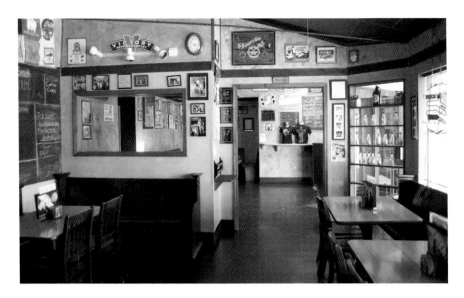

The front room at Rich O's as it appears today. It really hasn't changed much. *Cassie Bays photo.*

beers themselves; this led to the formation in 1989 of the LAGERS Homebrew Club, a group of like-minded beer enthusiasts who brewed their own beer. (LAGERS stands for Louisville Area Grain Extract Research Society.) About a year later, FOSSILS (Fermenters of Special Southern Indiana Libations Society) formed in southern Indiana at a brewpub called Rich O's in New Albany. The brewing bug was bubbling in Louisville, even though most didn't realize it.

LAGERS began when Bob Capshew was looking for a meeting place for area home brewers, and fellow home brewer Robin Garr, who wrote for the *Courier-Journal* at the time, placed a blurb in the newspaper's Saturday magazine, *Scene*. A restaurant owner named Martin Twist saw it and offered them such a place. It was at this place, called Charley's Restaurant, located at Sixth and Main Street, that Louisville commercial brewing symbolically drew its first breath since the closure of Falls City more than a decade earlier.

Twist told the LAGERS club that he had a brewing license, so members went to work creating a craft beer that could be sold at the restaurant. One of these young brewers was David Pierce, who had acquired a recipe for Sierra Nevada Pale Ale from a CompuServe beer forum. He cultivated some yeast from a bottle of Sierra Nevada, and LAGERS created a Sierra Nevada clone that, for some reason, would later be tapped and sold for a short time as

Charley's Cream Ale. "You don't hear much mention of [Charley's] because we only brewed about fifteen gallons of beer," Pierce said. Nevertheless, Charley's was Louisville's first licensed brewer since Falls City.

It was not long after that time that David Barhorst, along with a brewer named Toby Hunt, would briefly resurrect Oertel's. There was also talk of a brewery opening at the former Anthony's by the Bridge at Second and Main, and Pierce and Capshew briefly discussed opening a brewery at Eighth and Main. Those wouldn't come to pass, but the fire under the kettle had been lit and wasn't about to burn out.

Pat Hagan, meanwhile, was a young home brewer who had his sights set on brewing commercially as well. After he graduated from high school in southern Indiana, fueled by a relentless sense of adventure, he set off hitchhiking in California and eventually settled for a short time in the Santa Cruz/San Jose area. Chico, home of Sierra Nevada, is just about an hour north of that area, and it was then that Hagan developed a love for hoppy California-style pale ales.

Hagan would go back and forth between California and Louisville for several years, and he eventually caught the brewing bug. Home brewing led to an intensive brewing education at Sieble Institute in Chicago, and soon he had a vision to brew for a living—he had seen that craft beer (back when it was still just called "beer") could work in America. If it worked in California, why not Kentucky? Who cares what Mark Twain did or didn't say.

David Pierce, who then worked in construction, had the same dream. He had been brewing many different beer styles at home and was similarly looking for an opportunity to do what he loved for a living. But there simply was no option to do so in Louisville.

Pierce became interested in brewing because his father was a home brewer, as was his grandfather. In fact, Pierce's grandfather was also a bootlegger during Prohibition, and his still is now on display at the Bluegrass Brewing Company Tap Room on East Main Street in Louisville. Pierce said that the still had been built by one of his grandfather's friends—who was a police officer, no less—in exchange for a share of the product that the still would produce.

Pierce's father began brewing in a garbage can using handwritten recipes in about 1966; by the early 1970s, he'd purchased books on home brewing, which he shared with his son. The younger Pierce was hooked. As he grew older, he said, he developed a taste for imported beers, "and it just snowballed. I started brewing seriously in 1980."

One of the books his father gave him was *The Beginner's Home Brew Book*, by Lee Coe, which was published in 1972. "It was your typical, you know,

David Pierce
with his son,
circa 1993,
setting up
brewing
operations
at Bluegrass
Brewing
Company.
*Courtesy of
David Pierce.*

'three-pound can of malt and ten pounds of sugar home brew' recipes,"
Pierce said. "But Lee got into some different styles. Back then there *were* no
styles of swill."

He started ordering equipment and ingredients from home-brew suppliers
on the West Coast and found more books. "Most of the books available
then were British, so I started brewing all these British style beers." He also
got help from Winemakers Supply on Westport Road and could even find
malt extract at his local Kroger in New Albany. By 1989, LAGERS had
formed. Pierce was quick to get involved, which helped start him on his
path to becoming one of Louisville's best-known brewers—if not *the* best
known. For more than a decade, Pierce had basically operated a micro-
microbrewery out of his garage, producing hundreds of gallons of beer
annually for himself and his friends. It would eventually lead him to a life in
brewing, once an opportunity arose.

One Louisville-area beer enthusiast of the 1980s who *did* have a local
opportunity of sorts was Roger Baylor, also a New Albany, Indiana resident.
Back in high school, one of his buddies introduced him to Guinness, and
another introduced him to some good pilsner beers. Like many teenagers,
Baylor had a fake ID, and beer was an interest for him for the usual reasons.
But while most of us at that age were content with whatever was cheapest,

Baylor developed a taste for the interesting. It may simply be that his palate developed earlier than for many of us—he just didn't have access to much other than the typical corporate swill.

But a man named Ed Schuler, a local distributor, could see at that time that much of what he carried—Falls City and Sterling—was dying, so he would bring in imports, knowing that he had a few local customers, one of them being a Jeffersonville pizza place called Rocky's, where Baylor would hang out with his friends. This helped to fuel Baylor's interest in beer that had actual flavor. "Ed is kind of forgotten, and he shouldn't be," Baylor said, naming Schuler as an "unsung hero" of the Louisville area's beer scene.

Baylor was friends with Schuler's son, Chris, meaning he had access to that good beer in a more direct way than Rocky's could even provide. This interest led to him getting a job at a local liquor store called Scoreboard Liquors, and the owner let Baylor take ownership of one display door of the cooler to stock imports. "Nobody [at the liquor store] understood it, but they wanted to differentiate themselves by having it," Baylor said. He recalls carrying Lindeman's, Samuel Smith and the staple, Ayinger, almost constantly. "You could get Beck's, Bass, Guinness, Pilsner Urquell and Spaten occasionally," he said. "It was all the classic names that were going to be in [the late beer writer] Michael Jackson's book at the time. I got kind of ambitious every now and then; I was doing make-your-own-six-pack. Anything to move these along."

In 1985, he began traveling abroad. "After that," he said, "I'm hooked. The notion was that someday I would like to have some sort of place that would combine some of these things. But I didn't know what the hell I was doing."

He understood the need, however. He understood the importance of beer and what it had meant for so many thousands of years before temperance and Prohibition effectively squashed it under the weight of a moral crusade. "What I picked up [in Europe] when I was there in the '80s was that the lore and mythology is so much a part of the culture," Baylor said. "Old men sitting at the pub on Sunday afternoon waiting for women to get out of church. Festivals that all have to do with beer."

As we learned early in this book, beer was simply a part of life to those people. Perhaps one day Louisville will return to that. If so, people like Pierce, Hagan and Baylor should be credited for helping put that in motion. All three emerged as major players in beginning to bring that feeling (and locally brewed beer) back to Louisville; they didn't do it

themselves (and indeed many names have been left out), but their legacies are still being written.

Let's start with the first *true* brewery to open in Louisville since the closure of Falls City in 1978.

THE SHORT-LIVED SILO BREWPUB

The Silo Brewpub—which would operate under the names Silo Microbrewery, Silo Microbrewery Complex and others before all was said and done—was a crazy, amazing surprise to me when it opened. It had beer other than the stuff I could find at the local liquor store? It had beer brewed here in Louisville? Brewed right here in this very space? And I get to look at the shiny, copper brewing equipment, sitting there like a bunch of copper-clad UFOs come to land, while I drink it? It was like going to Disneyland for grown-ups.

And so, thanks to Silo, I got my first official taste of fresh, local beer—that unfiltered wheat beer described in the introduction to this book. I had no idea at the time, but it was David Pierce who had brewed that beer for me. He was just getting started as a professional brewer, and I was just getting started as a full-on, no-holds-barred beer enthusiast. If I had a dollar for every Pierce-brewed beer I've enjoyed since that first wheat beer, I'd take all the money and spend it on more beer.

Anyway, Silo was situated near a huge grain silo at 630 Barret Avenue; it was also located just a few blocks from what once was Phoenix Brewery, and the Silo building still stands (as of this writing, it is a bar and entertainment complex). When it opened in 1992, Pierce was just reaching the point where he was fairly fed up with his job as a construction manager for a commercial interiors company, so he applied to two fledgling breweries—first to Oldenburg, a Fort Mitchell, Kentucky–based brewery that would later open a satellite location in Louisville, and then to Silo.

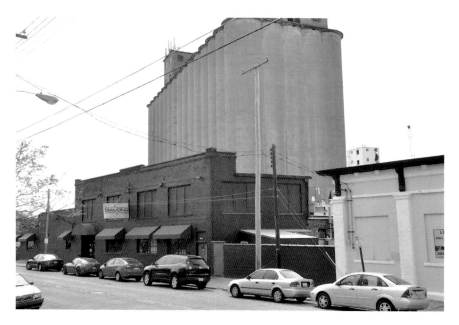

The former site of Silo Microbrewery. *Jeff Mackey photo.*

But instead of leaving it at submitting a simple résumé, he decided to take it a step further—he brewed several beers to serve as an example of what his first tap lineup might look and taste like. "I took a regular résumé" to the interview, Pierce said, "but I also poured them beer." This blew away the two other competitors for the position, and Pierce became the first head brewer for Silo. The owners, brothers Fred and Danny Radcliffe, operated an asbestos company and wanted to open their own restaurant and bar.

Silo is long since gone, but my vague memory of the place recalls an open space with high ceilings and lots of wooden booths and tables. I recall that the food was only OK but that the beer was interesting enough to make me return several times. The place had a big oval bar in the center, as Pierce reminded me during our discussions for this book, and the kitchen and brewing equipment were off to the right side of the complex as one entered the front door from Barret. There was also brewing equipment in the basement.

Pierce said that the Radcliffes had done a lot of research prior to opening by way of trying a number of unusual beers in various locations across the country—that's my favorite kind of research; almost from the start, though, things didn't go as planned.

"When I started there, we only had four taps," Pierce recalled. "One of them was supposed to be a rotating seasonal tap. It came down to three weeks before the opening date, and they wouldn't tell me what they wanted. They said, 'We want a Miller Lite and a Killian's Red and something dark, and none of them can have any aftertaste.' They'd had a blueberry beer that had blueberries floating in it, so they also wanted some sort of fruit beer. I had a line on some natural raspberry extract, so that was our first fruit beer."

The problem is, Pierce didn't have time to brew much beer before the grand opening. As such, the influx of interested beer drinkers consumed the first barrels quickly. So, the owners bought kegs of beer from the aforementioned Oldenburg and sold it as Silo beer. And so, the early beers Pierce brewed included Red Rock Ale, Silo Premium Light, River City Raspberry and a dark Brewer's Favorite. Pints were $1.95. If you were there and noticed the flavor fluctuating in the early weeks, you now know why: some of the first Silo beers sold were not Silo beers at all.

"The owners would back a truck up to the walk-in cooler and sell them as Silo beer," Pierce said, referring to it, tongue firmly in cheek, as "inter-brewery transfer." But things improved a bit, at least in terms of the leeway. In late 1992, the owners allowed Pierce to brew a Christmas ale, and that won a silver medal at the Great American Beer Festival. They also let him do an oatmeal stout at one point, as well as an English old ale called Hercules that had a 6 percent ABV punch.

Of course, there was also the American wheat ale, which quickly became popular and even got plenty of media attention with its "Wheat Your Whistle" advertising slogan and its unusual cloudy yellow appearance. (Pierce said that keeping it as cloudy as possible was actually a forethought; the kegs were stored upside down to prevent the beer from settling.)

But the owners mostly kept a tight rein on Pierce's creativity, which frustrated him. "It was like pulling teeth to get them to let me brew anything," he said. "We went from brewing at capacity to brewing twice a month in a very short time. Anytime I would brew a specialty beer, it would sell out."

Early in his run there, as the brewery was being set up, another local home brewer named Eileen Martin would end up working with him; he knew her through the LAGERS club and asked her to bartend. Her experience echoes Pierce's. "They just weren't into [the brewing part of the business]," she said. "It was basically a place for them to hang out and call their own."

Nevertheless, it was a commercial brewery—brewing in Louisville was back. It was a big deal for everyone involved, even if no one quite knew how to market the place or the products. And it got favorable reviews initially;

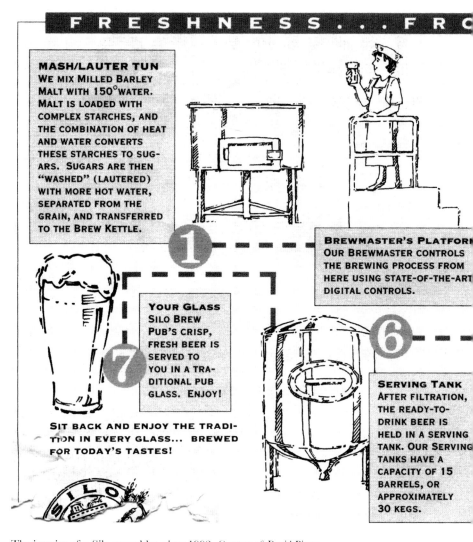

The interior of a Silo pamphlet, circa 1992. *Courtesy of David Pierce.*

Courier-Journal food writer Susan Riegler praised the value, food quality and mood in a November 14, 1992 review. She tasted the Premium Light, River City Raspberry, Red Rock and Brewmaster's Favorite, which reminded her of "dark German pilsners."

Her complaint was that the beer was served too cold. "At least Silo doesn't indulge in the travesty of a frosted mug," she noted. It is a fair point. Still, it was fresh beer, in Louisville, for the first time in years. "It was exciting

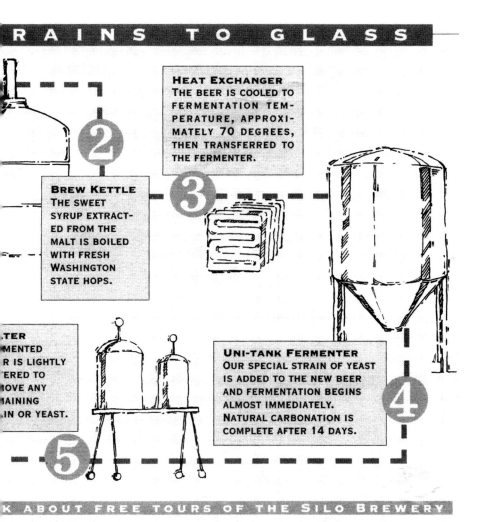

RAINS TO GLASS

HEAT EXCHANGER
THE BEER IS COOLED TO
FERMENTATION TEM-
PERATURE, APPROXI-
MATELY 70 DEGREES,
THEN TRANSFERRED TO
THE FERMENTER.

BREW KETTLE
THE SWEET
SYRUP EXTRACT-
ED FROM THE
MALT IS BOILED
WITH FRESH
WASHINGTON
STATE HOPS.

.TER
MENTED
R IS LIGHTLY
ERED TO
IOVE ANY
1AINING
IN OR YEAST.

UNI-TANK FERMENTER
OUR SPECIAL STRAIN OF YEAST
IS ADDED TO THE NEW BEER
AND FERMENTATION BEGINS
ALMOST IMMEDIATELY.
NATURAL CARBONATION IS
COMPLETE AFTER 14 DAYS.

K ABOUT FREE TOURS OF THE SILO BREWERY

FRESHEST BEER IN TOWN.

because it was Louisville's first brewpub," Martin said. "It was something brand new. It was hard because it was such a new concept, trying to get people familiar with craft beer."

Less and less focus was being placed on the brewing side of the business, as the Silo management and ownership seemed intent on having the place be a nightclub, Pierce said. There was an, "Oh, and we have our own beer" attitude toward what was originally supposed to be the focal

A collection of Silo breweriana. *Eileen Martin Collection; Cassie Bays photo.*

point. It prompted Pierce to resign in May 1993. "When I left, there still were only four draft lines, and they had eighteen different domestic and/ or import bottle beers," Pierce said. "That was what really sealed the deal with me."

Local brewers Martin, Brian Cobb and Matt Gould would get involved in brewing for Silo, but it didn't take long for the place to fall on hard times. In November 1994, the *Courier-Journal* reported that Silo Microbrewery had filed for Chapter 11 reorganization in U.S. Bankruptcy Court. It was later turned into a bar and restaurant called Louisiana Jack's and has been open off and on as various bar and music venues ever since.

"We were obviously hoping for more and a better outcome than what came about," Martin said. "Plus, I was involved with the whole installation process. That was probably my first recipe-type formulation experience. Then, that just lit a fire under me for home brewing."

Martin recalls brewing what she termed a "mocktoberfest" beer at one point, but the tap situation didn't change much. She and Gould, it should be noted, would later get involved in the launches of two other Louisville breweries (which we will visit a bit later).

The leftover Silo brewing equipment, Pierce said, had to be lifted out through the roof by crane. It was sold to an Indiana businessman named Clark Nickles, who stored the equipment outside on a flatbed trailer in Utica, Indiana, in the hopes of selling it. The copper top on the kettle "sat out there and turned green," Pierce said.

But that didn't kill brewing in Louisville the way the demise of Falls City did at the time. As I mentioned earlier, plenty of people were brewing beer around the city—they just had no outlet to do it commercially. Not long after Silo opened, a high school acquaintance of Pierce's, Pat Hagan, stopped in looking for a brewing job. For a time, he was Pierce's volunteer intern, as he was studying brewing at the aforementioned Sieble Institute.

So, a few months later, when Hagan was preparing to open Bluegrass Brewing Company, it was only natural that he would turn to his friend Pierce for assistance. That's why Pierce ultimately left Silo, leaping from a sinking ship onto one that had a long and prosperous journey ahead of it.

BLUEGRASS BREWING COMPANY LEADS THE WAY

If there is a flag-bearer for Louisville's current brewing scene, it's Bluegrass Brewing Company. Not long after it opened, in late 1993, it became my go-to place. Heck, it became a go-to place for a *lot* of people in Louisville.

Interestingly, the spot isn't much different now than it was in the early days. A bar added to the dining room has since been removed, but the signature booths opposite the brewing equipment—which sits behind glass, keeping watch on people as they dine—have remained. The oval bar has been stripped down in recent years; it originally was adorned with a raised wood perimeter from which hung dozens of glass mugs belonging to members of the "Wort Hog" club. The club still exists, however, and walls upon walls are still filled with hooks that bear the weight of hundreds of Wort Hog mugs.

These days, there is also a covered outdoor patio that didn't exist when the place opened. But the iconic brewpub in the St. Matthews area—which sits very near where Daniel Gilman's tavern was located in the late 1700s—has endured and prospered, offering quality craft beer, solid pub food and one of the most welcoming atmospheres in the entire city.

Hagan—a slender, dark-haired, bearded man with a quiet demeanor—was meticulous in planning the brewery, with Pierce as a co-conspirator. Hagan's father also was a co-founder of Bluegrass Brewing Company, which is known to most these days simply as "BBC." Pierce was heavily involved in creating the logo and the initial products; Hagan was and remains to this day the guiding force.

Moving equipment into Bluegrass Brewing Company, 1993. *Courtesy of David Pierce.*

Bluegrass Brewing Company labels. *Paul Young Collection; Jeff Mackey photo.*

When Hagan finally settled in Louisville, as we know, his first goal was to open BBC. He studied brewing, did his internship at Silo and signed the lease for BBC's location at 3929 Shelbyville Road, a former restaurant, in April 1993. Pierce came on board a few weeks later and began the process

of directing the setup of what would become Louisville's enduring, signature brewery, right down to the logo and the style of glassware. "I got to set up and open two breweries in the course of the year," Pierce said. "It was fun. I also developed some pretty severe OCD."

OCD indeed. To this day, Pierce has a binder filled with carefully printed and documented (on green paper) formulas for the beers he has produced over the years. The early beers at BBC were Robust Porter (later to be renamed Dark Star Porter), Altbier (a German-style amber), Bohemian Pilsner, Brown Ale and ESB. The first specialty, or seasonal beer, was American Pale Ale, a firm, medium-hopped ale that is now an everyday staple. (It tastes great with the BBC wings.)

BBC opened with a fifteen-barrel brewhouse with three fifteen-barrel fermenters and two seven-barrel fermenters in a relatively small space, so it could realistically have eight different beers on at a time. The Bohemian Pilsner took a lot of time to brew, so it was dropped fairly quickly. A mead beer was added in its place. For better or worse, the response was so overwhelming that Pierce could barely keep up. Keeping the taps flowing was a process that offered no reprieve in the early days. "I didn't catch up," Pierce said. "I had all the serving tanks full and all the fermenting tanks full when we opened."

It wasn't until January 1994 that he actually got caught up, and it was by the grace of Mother Nature herself, who dumped a snowstorm on Louisville that had the city mired for days. "We didn't catch up at BBC until that big-ass snowstorm dumped twenty-some-odd inches on us in '94," Pierce said. "The whole city of Louisville was shut down. Pat's wife had an old-school Land Rover, and she picked me up and dropped Pat and I off at BBC the second day of the storm. We went in and started filtering beer. We emptied three of the four tanks and got beer back online. That was when our first mead went on. I remember we got really drunk pulling samples off the filter."

On the third or fourth day of the winter storm of 1994, BBC opened with bar service only, except for some chili that was available from behind the bar. The next day, they opened a rudimentary self-serve food line, with one of Hagan's brothers-in-law serving as a sort of short-order chef. People in the nearby neighborhoods trekked there to get their fill. "We had snowshoes and cross-country skis lined up along the wall," Pierce recalled. "We were giving food away."

On Friday of that week, probably five or six days after the blizzard, Pierce and Hagan drove and picked up the kitchen staff so that BBC could open for lunch. The interstates were mostly still closed. But in true Louisville brewing

spirit, BBC was making sure that the city could get its lips around a locally brewed beer. Something tells me that Frank Fehr and John Oertel would have been proud.

BBC continued to thrive through the 1990s; at the end of 1997, I was working for a small alternative newsweekly called *Louisville Eccentric Observer* (now *LEO Weekly*), which had its offices across the street. We published every Wednesday, and our deadline was 3:00 p.m. every Tuesday afternoon—so BBC became my deadline day reward, which is how I came to know Pat and David.

By 2000 or so, I had seven or eight friends who would meet me every Tuesday for happy hour at BBC, and by then one of the staples was a German-style kolsch beer. My friend Sara would, for an extra dollar, get a "shot" of the raspberry mead in her kolsch to add a bit of a fruity side to the crisp, light beer. Meanwhile, the wings during happy hour were a quarter each, and if you were a Wort Hog Club member, you got even better deals.

BBC also was active in the community, sponsoring events; holding events at the brewery; having local, regional and touring musical acts there; and generally being part of the local landscape. That was always one of Hagan's top priorities. As such, charity events are the norm at BBC and always have been. "You have to be part of whatever neighborhood you're in," Hagan said.

In 2001, BBC bought out a struggling brewery called Pipkin and turned it into a downtown production and bottling facility, with an adjoining taproom and beer museum, which is filled with local breweriana focusing largely on Oertel's, Fehr's and Falls City memorabilia—oh, and of course the still that was owned by Pierce's grandfather.

In addition, a separate downtown location at 660 South Fourth Street opened in 2006. BBC was far and away the brewing leader in Louisville and continues to be the model for a successful brewery. But Pierce finally decided to move on in 2009 after sixteen years with the company.

While the seasonals continue to change and develop—a recent run of IPAs has been a delicious and welcome addition to the BBC rotation—many of the mainstays that began with Hagan and Pierce's first few months remain, such as Altbier, Brown Ale (now Nut Brown Ale) and Dark Star Porter.

In 2009, Bluegrass Brewing Company opened yet another downtown restaurant location, which is served by the main production plant—the newest BBC is a $1.4 million, two-story gastropub and brewery at Third and Main Streets, directly across the street from the Yum! Center, a huge arena where sporting events and concerts are constant, bringing heavy traffic to the brewery.

Pat Hagan with a wall of Wort Hog mugs. *Cassie Bays photo.*

Brand recognition as the first modern Louisville brewery likely will ensure BBC's continued success (well, along with the good beer). In fact, it has become such an institution that many don't even go for the beer these days. "BBC survived partly because there was no competition, and after twenty years, it's just local," Pierce said. "There are people sitting around the bar that don't know anything about the beer. They just like the way the bartender makes their vodka cranberry."

Hagan attributes it to "good beer and a lot of luck." In a 2013 interview, he said about BBC's longevity, "Luckily, I've had some good brewers. That was the key—having good brewers and making great beers." I asked Hagan if he considered himself a Louisville brewing pioneer, and he quickly noted that Daniel Boone was in BBC's original logo. "Maybe he was the beer pioneer," Hagan said.

Still, he admitted that he believed from the beginning that craft brewing had a future in Louisville. "You know, I thought it would. I think it took a lot longer than I anticipated, at least in our areas. I think it was two years ago, Lexington didn't have anything, and I think there are now, what, four down there? It's amazing the way it's taken off. Hopefully things will keep rolling."

As of this writing, Hagan was about to embark on another beer-related venture: a taproom-meets-restaurant that will focus on Kentucky beers and Kentucky recipes. Expect to find plenty of BBC beer there when it opens.

NEW ALBANIAN BREWING EMERGES

The story of New Albanian Brewing, based in New Albany and masterminded by Roger Baylor, is a bit of a complicated one. The business began as a pizza place and was operating as a restaurant as early as 1987; Baylor would come in later, but right from the start, of course, he knew that he wanted to feature imported and craft beers.

Brewing was always in the long-range plan, as well, but first came Rich O's Public House, which actually originated as a barbecue place run by Baylor's (then) future father-in-law, Rich O'Connell. By 1992, Rich O's was a full-on pub that featured imported and craft beer from around the world. It quickly became a popular spot, in no small part due to its eclectic beer list and proximity to an Indiana University satellite campus. The Red Room, a communism- and socialism-themed area, is another reason. Everyone wants to sit in the Red Room.

In 1994, O'Connell departed, and Baylor took over with his new wife, Amy, and her friend Kate, starting a new company in the process. The business ran as a split concept, with one side being Sportstime Pizza and the other being Rich O's. The import beer–loving crowd gravitated toward Rich O's, while Sportstime was and still is more geared toward mass consumption.

In a move that would endear him to Rich O's regulars and alienate swill-chuggers, Baylor ultimately stopped selling mass-produced light beers of any kind at Rich O's. This happened on January 1, 1994, and he hasn't sold a light beer there since; Sportstime followed suit in the early 2000s. In fact, the

Roger Baylor in the Red Room. *Cassie Bays photo.*

Public House in particular still has something of a reputation for not being terribly friendly to those who come in and ask for a Bud Light.

Another trademark of Rich O's was Baylor's beer list/newsletter, a binder filled with pages upon pages of beer descriptions, articles, opinions, quizzes, excerpts from Baylor's *Walking the Dog* newsletter and general snark. There were always several of these within reach at Rich O's, and skimming through it was half the fun of going.

I particularly remember an early description of Corona, the Mexican beer that has taken its place as one of America's more popular corporate beers. The description said, "Cheaply made, corn-choked, watery-tasting, sweetish lager brewed in Mexico as a discount thirst quencher, then shipped to America to be violated with lime wedges. Why, God, why?" And if you ordered one, for the trouble, you had to pay fifty cents extra for the lime.

Baylor let me borrow a 1999-era version of this Rich O's beer bible, and in it I found a few fun memories, such as this gem of a quote from Herr Trumm, owner of Germany's Braueri Heller-Trum: "We don't try to make a beer for everyone. You like it—or you don't." There's also a nice description of popular 8.5 percent ABV Belgian beer Duvel that ends with, "Not to be trifled with. But some try."

A brew kettle at New Albanian. *Rick Evans photo.*

With brewing still on his mind, Baylor's chance finally came in 2000. He and Amy had bought into the short-lived Tucker Brewing Company in Salem, Indiana, and when the dot-com fallout essentially killed the brewery—it had been funded by dot-com money—he had an idea. "I told [the principal owner], 'I know I'm not getting the money back; let's talk about the equipment,'" Baylor said.

By October 2002, New Albanian Brewing Company was producing beer, with Michael Borchers as head brewer. He was replaced in 2005 by Jared Williamson and Jesse Williams, turning out now-popular beers such as Hoptimus, a heavily hopped IPA, to go with staples such as Community Dark, a light-bodied brown ale. They also added Beak's Best, a medium-hopped American ale, and Elector, an imperial red ale, which remain staples today.

By the mid-2000s, Baylor said, he was "getting bored" and had become interested in "new urban thinking." New Albany's downtown had been fairly dormant for years, but Baylor saw it as an area of the city that had plenty of potential. He began pondering putting a brewery downtown and ended up taking over a former Rainbow Bakery store and turning it into the Bank Street Brewhouse, complete with a fifteen-barrel brewing operation and restaurant.

In February 2009, Bank Street began brewing and serving food (it has since abandoned food service to become simply a taproom); it was one of the businesses on the leading edge of what is now a full-fledged resurgence in New Albany's downtown district. David Pierce defected from BBC and remains head brewer at Bank Street Brewhouse. With the uptick in production capacity—Baylor said that Bank Street is inching up toward two thousand barrels per year, compared to a capacity of about four hundred at the original location—bottling and regional distribution are in place.

Perhaps one of the coolest features at Bank Street Brewhouse—aside from the amazing beer lineup, of course—is the way the fermenting vessels are labeled. Due to government regulations, all vessels must be identified, and in most breweries you'll see them tagged "Fermenting Vessel No. 1," "Fermenting Vessel No. 2" and so on. At Bank Street, they are named after communist and socialist leaders. So it's not uncommon to hear Pierce ask one of his associates how Trotsky is doing.

With two breweries producing great beer, Baylor's longtime goal is being reached; with Pierce on board as director of brewing operations and a brewing team that includes Ben Minton, Josh Hill and Peter Fingerson

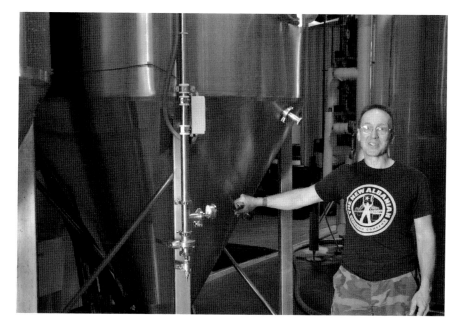

New Albanian brewer David Pierce. *Rick Evans photo.*

in place, New Albanian continues to brew some of the best beers in the Louisville area. Just be forewarned: If you go, don't order a Corona. And say hello to Putin for me.

PIPKIN BREWING

Paul Hummer was the brains behind Pipkin Brewing Company, which occupied the space that is now BBC's production brewery and taproom at Clay and East Main in Louisville.

I remember being on a media tour of the facility and trying the beers for the first time. Hummer also took us up some narrow steps to look down into the mash tun and warned us, "Be sure to not hit your head—that's cast iron above you, and it hurts really badly." I ducked but still managed to graze the cast iron—it was so painful it almost doubled me over. Hummer asked if I was OK and I shrugged it off, but I can still remember the intensity. Ouch.

Anyway, some of the beers that came out of that brewery included Pipkin Blonde, a crisp, heavily carbonated light ale; Pipkin Porter, a malty, chocolaty beer; Pipkin Brown Ale, a mild brown that I remember as having just a bit more body than Newcastle; and Pipkin IPA, which was a fairly tame version of an India pale ale style at just 5 percent ABV. Another beer that Pipkin brewed was Louisville Ale, a red ale that featured a bright-red label with a black cardinal head as the logo—it was designed to attract fans of University of Louisville sports, whose mascot is the Cardinals and whose school colors are red and black. Blue Brew was the University of Kentucky–themed sibling.

Pipkin was so named because it used an English-style Pipkin barley malt in its Pipkin Pale; interestingly, a 2002 beer-a-day calendar included Pipkin Pale and said that the style of malt is "rarely used because of its relatively high cost. The variety's hallmark is a very intense, biscuity malt flavor."

Paul Hummer's story is similar to Pierce's, at least from its beginnings. When Hummer was fifteen or so, his dad began brewing voraciously in the basement of the family's home, and Hummer apparently caught the bug. After high school, as many of his friends were heading off to college to *drink* beer, Hummer studied how to brew it at the University of California–Davis, where he majored in brewing studies. After he had earned his degree, he worked for four years at Weeping Radish Brewery in Durham, North Carolina, where his wife was finishing her PhD, and then finally landed in Louisville with the plan to open his own brewery, spurning New York and Chicago in the process.

"I had it in my mind that I wanted to open a brewery," Hummer told me in 1999 during an interview for *Louisville Eccentric Observer*. "My wife was about to graduate, and we were looking for a place that didn't have many breweries, a place where she could get a job, and a place we would like."

The Pipkin malt was his favorite (inspired by Belgian brewery Chimay), and thus, Pipkin Brewing was born. He was quoted by BeerMonthClub.com as saying, "The Pipkin malts lend a depth of flavor to the beers which can only be achieved with superior raw ingredients."

According to Louisville's *Business First* publication, he and his home-brewing father funded the brewery with $600,000 of their own money and a pair of small business loans. Hummer hired a salesman and a brewer, Mitch Turner (who later defected to Schlafly in St. Louis), and by 1998, Pipkin's twelve-thousand-square-foot brewery was up and running, cranking out 1,200 barrels per year. After Turner left, Paul Phillipon came on board, and for a time the brewery did well.

In fact, in fairly short order, Pipkin's brewery and small bottling line were also contract-brewing a few beers for BBC. But the operation was big, and the market and awareness for craft beer simply wasn't there yet. Of course, the corporate breweries also took every opportunity to squeeze the little guy.

In an interview with EdibleCommunities.com, Roger Baylor—never one to keep his opinion a secret—brought up an interesting point. I fully remember Roger telling me at the time that he thought Pipkin's bourbon barrel beer was by far the best thing being brewed there, and he told that website, "The best beer he ever did was bourbon barrel beer. David Pierce…and I told him, 'Make this whole thing about bourbon barrel beer,' but he didn't do it and he went broke. 'Kentucky Bourbon Barrel Aged Beer made in Kentucky!' Blows my mind that no one has taken advantage of that on a truly big scale." There's that bourbon angle again. Interestingly, in recent years, Alltech, a brewing and distilling company in Lexington, has

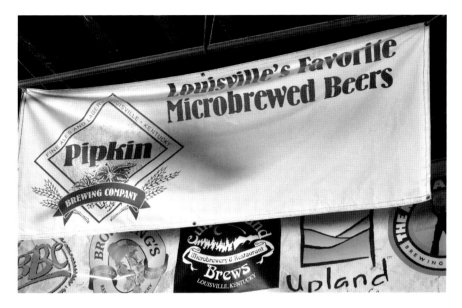

An original Pipkin Brewing banner. *Private collection; Rick Evans photo.*

found plenty of success with its Bourbon Barrel Ale. So at least someone was paying attention.

By 2001, Pipkin was floundering to the point that it could no longer survive on its own; BBC and a group of thirty or so investors—comprising mostly BBC regulars—bought 51 percent of the operation on July 1 of that year. Pipkin beers continued to be brewed and distributed for a time, but the brand died a slow death; BBC would ultimately take over. Today, Hummer works in investment management, according to his LinkedIn page.

While Pipkin's demise was unfortunate for Louisville's brewing scene, which was trying its best to take off, it also was a positive turning point for BBC, which bought the brewing and bottling operation, its first expansion move of several to come over the next few years. And while Pipkin's large operation didn't survive, a small operation came onto the scene during that time that provided a business model that many of Louisville's breweries embrace today.

CUMBERLAND BREWS

If "go big or go home" is the mantra for many these days, Cumberland Brews' stay-small approach has proved it wrong to an extent. Cumberland opened in 2000 in its teeny-tiny space at 1576 Bardstown Road in Louisville's popular Highlands neighborhood, and other than expanding upward to include a few more tables and some lounge space, it has held steady. Of course, there is also now an off-site brewing facility to meet demand—which is another clue that Cumberland is doing something right.

Owner Mark Allgeier, who had previously helped park planes for United Parcel Service, started Cumberland with his wife, Julie, and brewer Matt Gould, who had previously worked with David Pierce at BBC. The space had served as a White Mountain Creamery ice cream parlor, but Allgeier reimagined it as a two-barrel brewery.

The Allgeiers launched the operation on the cheap (well, as cheap as opening a restaurant and brewery gets, anyway) by traveling around the country and collecting used machinery, including their two-barrel brewing system that came from Elliott Bay, Washington. It's one of about thirty of its kind in the country, he told *Business First* at the time. But the traveling paid off. The Allgeiers spent $30,000 for equipment that would have cost nearly $150,000 new at the time, he said.

The cozy space featured a handful of English-style beers, good food from Chef James Rakestraw and an undeniable appeal that still exists. In fact, it's tough to get into Cumberland most days, in part because of its size but also because of its location and popularity. The four small tables that sit on the

Tap handles and the what's-on-tap board at Cumberland. *Rick Evans photo.*

Brewer Cameron Finnis of Cumberland Brews. *Rick Evans photo.*

sidewalk outside the brewpub are prime real estate during summer months. It was designed that way; from the word "go," the Allgeiers wanted a cozy neighborhood brewpub, not a party destination. "It's fine to go out and get wild," Allgeier told *Business First*. "Just not here."

According to a *Business First* story announcing the brewery's opening, the first four brews were a nitrogen-charged porter, a pale ale, a nut brown and a wheat ale. Later, mead, brewed with 75 percent honey, and cream ales were added to the list of staples.

Matt Gould, who had worked at Silo and later at BBC with Pierce, would brew at Cumberland until 2008. He later returned to BBC as part of its downtown production location until his untimely passing (following a battle with cancer) shook the local brewing community in October 2012. In a tribute on his blog, the Potable Curmudgeon, Baylor called Gould "a Louisville brewing legend."

Today, brewer Cameron Finnis stretches the limits with a variety of limited releases of varying styles, and the day's brews are always on display on a chalkboard behind the bar. Recurring favorites such as Moonbow Vit and L&N #152 are just two highlights. Cumberland continues going strong.

One of the staples at Cumberland is the collection of breweriana that adorns the wall behind the bar, the captivating mural intertwining a brewery schematic with faux brick and, perhaps most notably, a sizeable beer can collection that occupies an entire wall in the men's room and part of a wall in the brewpub's upstairs. (This must be seen to be believed. Trust me.)

Most of the brewing today is done at the off-site fifteen-barrel facility in Louisville, but Finnis uses the small in-house system to get creative. "With the two-barrel," he said, "we can try anything. It's almost home-brewing size. The risk factor is not big." The deliciousness factor, however, is huge. Finnis has kept many of the old favorites, but he's brewing up bigger and better things every week, it seems. Long live the little guy.

BASEBALL AND BROWNING'S

What better place to enjoy a cold beer than at a baseball game? Browning's Brewery had the right idea when it opened in 2002. Named after Pete Browning, a star player for Louisville's baseball teams of the late 1800s, and nestled in Louisville Slugger Field (in a complex that was once a train station) in the city's downtown, it appeared primed for success.

And for many years, succeed it did. Eileen Martin, the brewer we met earlier, was on board as head brewer, and the team of investors created a beautiful bar and restaurant, featuring a grand view of the copper-trimmed fifteen-barrel brewing operation behind glass. The patio facing Main Street made the place that much more enjoyable, and the food was solid. But it was the brewing equipment that excited Martin.

"Well, look at it," she said while talking to me for this book at the old Browning's location, which is now a brewery called Against the Grain Brewery and Smokehouse. "Being involved from the ground floor up and going with just an empty space and doing all the paperwork, finding the equipment that was right for us. They wanted showpiece equipment. Being at the ballpark—it was very exciting. I was on top of the world at that time."

Martin started out brewing Blonde Ale, Red Ale, Oatmeal Stout, ESB and Cream Ale, and as one would imagine, the place was packed on game days. But she expanded to do hefeweissens and lagers, which most breweries at the time weren't doing. Unfortunately, Browning's would end up with a fate similar to that of Silo—the ownership group was primarily restaurant focused, and Martin feels the brewery side of the business may have been overlooked.

The former Browning's as it appears today (as Against the Grain). *Cassie Bays photo.*

Browning's was a sister business to Wellinghurst Steakhouse, which was also located in Slugger Field. Martin said that the rush to open them at the same time might have hurt both. The steakhouse would later close, and Browning's seemed to be always in flux. "They never wanted to make it a sports bar, being at the ballpark, which made no sense," Martin said. "I had been here for two years and brought in all my breweriana and put it up. After two years, it then became 'tacky,' and I was asked to take it all down. I felt the place needed some type of character."

Well-regarded local chef Anoosh Shariat came into the fold in about 2005, and Martin was replaced by Brian Reymiller, who brought some good brews with him. She-Devil Imperial Pale Ale would come along later and was a must-have.

Events at the brewery drew big crowds, one of the most memorable being the annual St. Hildegard Festival, in honor of St. Hildegard von Bingen, the first brewer to put hops in beer. St. Hildegard Helles was brewed for this event, and people sat around on the deck, beer garden style, and drank beer from huge porcelain mugs.

However, financial issues forced Browning's to close for a while in 2008. It reopened in 2009 with new ownership and the well-known Shariat trumpeting a new menu. Browning's would then become known as Browning's Restaurant & Brewery, which was telling—the restaurant end of the business had clearly become the primary focus by that point. It seemed to become a restaurant that also brewed its own beer.

And that is a shame, as by then Reymiller was brewing some really good products. But looking back at media coverage of the brewery and its changing of hands, it's clear that Shariat was the focus of every story, setting up culinary expectations that perhaps overshadowed the brews. Nevertheless, by 2007, Browning's was bottling its Bourbon Barrel Stout (there's that idea again) and selling it locally, and yet even Reymiller believed that the restaurant was the focal point.

"The restaurant makes it possible," Reymiller told *Business First* in 2007. "The restaurant generates revenue every day. If it were just a microbrewery, the only time we'd get paid is when the distributor comes in."

But due to the ongoing corporate stranglehold by the big brewers, Browning's beer couldn't even be purchased inside the park, which is still dominated by Anheuser-Busch products. One would think that there would be a way to offer at least one or two beers brewed (literally) at the stadium to be enjoyed during the games. But it would never come to pass.

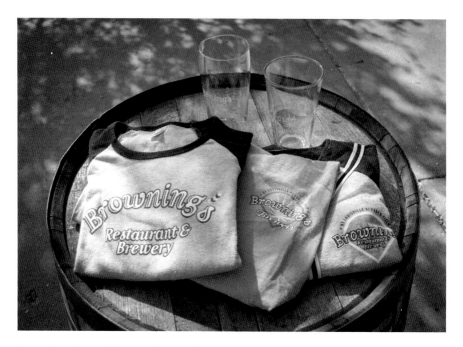

Some Browning's shirts and glasses. *Eileen Martin Collection; Cassie Bays photo.*

Browning's lasted until 2011. I, for one, being a regular at Louisville Bats baseball games, was disappointed. But as I recall, only a few weeks after Browning's shut its doors for good, signs went up in the windows announcing the forthcoming arrival of Against the Grain in the location. Brewing at the ballpark would continue on.

THE LOUISVILLE BREWING
SCENE GOES "BOOM"

I couldn't possibly devote an entire chapter to every Louisville brewery…and that's a good thing. But there are a few more up-and-comers that I want to recognize.

AGAINST THE GRAIN BREWERY & SMOKEHOUSE

Browning's was taken over by former BBC brewers Sam Cruz and Jerry Gnagy, as well as Adam Watson and Andrew Ott, and it immediately took a different approach to brewing its beers. Rather than maintain regular beers and supplementing with seasonals, Against the Grain maintains an ever-rotating list of beer categories: Session, Hop, Whim, Malt, Dark and Smoke.

Guest taps may be beer from another craft brewery or a keg that has been moved out of a category to make way for something new. But whatever the case, you never know quite what you're going to get when you walk in and check out the chalkboard trumpeting what's on tap.

The elevated copper-accented brewing operation remains and glistens over the bar behind glass. The wooden tap handles subtly suggest the style category, and the beers are always changing. The creativity in use of flavors, malts, hops, barrel aging and smoking extends to the beer names and even the artwork in the brewery's bottled products. One recent brew, a

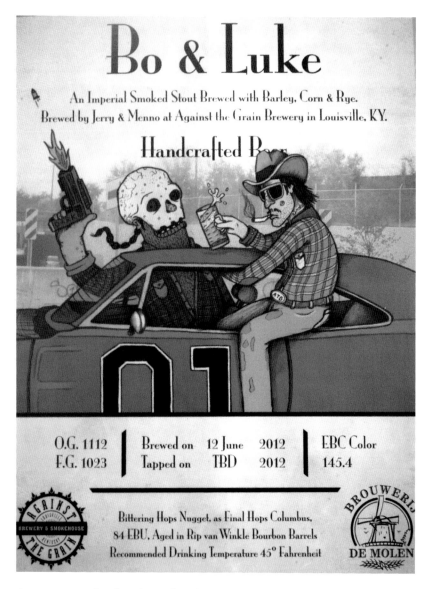

A poster trumpeting the release of Against the Grain's Bo & Luke. *Cassie Bays photo.*

Citra-hopped IPA, was called Citra Ass Down. One dark beer that returns sometimes is called the Brown Note. There was an oyster stout called We Shuck on the First Date. Mopery with the Intent to Creep. Beerknuckle Bockser. You get the idea.

There's also a popular Bo & Luke series that beer lovers from all over clamor for when the releases happen. The original Bo & Luke features the same ingredients that are in bourbon whiskey—corn, barley and rye—smoked with cherry wood and brewed into an imperial stout. Then it gets aged in Pappy Van Winkle bourbon barrels.

Check out the beer sites like BeerAdvocate.com. Against the Grain (or ATG, as it is often called) has quickly become a destination for hardcore craft beer lovers. In short, keep your eyes on these fellows. And if you're in Louisville? This is a must-visit.

FALLS CITY II

In 2009, a businessman named Dave Easterling bought the Falls City brand and brought it back to life in the form of Falls City Original Pale Ale, which is based on a Falls City English Ale dating back to the 1930s. "We don't have the exact recipe for that [original] ale," Easterling told me in 2010, "but assumed it to be an English pale ale, which was also the most popular ale style at the time, so we brewed our new beer to that style."

A small, on-site brewing operation cranks out a few experimental brews, while most of the beer is brewed off-site. The Original Pale Ale is a mild, malty staple, and joining it are Falls City Wheat Ale and rotating seasonals like Kentucky Waterfall IPA, Bourbon Barrel Red Ale and Hipster Repellant IPA (a personal favorite).

The Falls City taproom, which was open on Fridays and Saturdays, had a mini-museum of Falls City artifacts, including old advertising signs, photographs, beer bottles and more. I found the vintage breweriana to have a nostalgic mystique to it, and friendly beer slinger Rob Haynes was usually around to banter with regulars and talk beer. As of this writing, the new Falls City had announced a partnership with Old 502 Winery and had moved the local brewing operation and breweriana to a new shared space with the winery. Wine and beer in one stop? Not a bad way to spend an afternoon.

APOCALYPSE BREW WORKS

Leah Dienes and Bill Krauth are partners-in-brewing at this tiny brewery on Mellwood Avenue, just a few blocks from where Oertel Brewing Company once stood. Dienes, an award-winning home brewer, and Krauth typically have ten beers on tap, and most are sessionable and accessible.

The Apocalypse taproom seats maybe twenty people, and beer is served by the pint or half pint in clear plastic cups. A huge courtyard outside is home to food trucks and picnic tables on Friday and Saturday nights. The regulars are fun, friendly people.

Apocalypse-themed décor (gas mask, anyone?) and a flat-screen TV that is usually showing B-grade horror movies helps set the tone, and a chalkboard on the main wall next to the bar lets you know what beers are on tap. There's a regular rotating ale, plus the Cream-ation cream ale, the peppery Fallout Dust, Atomic Amber and the gluten-free Danny O'Pivo, among others.

Dienes, of course, teamed up with Selle in the spring of 2014 to brew Oertel's 1912, and she said that more Oertel recipes may follow. Meanwhile, she continues to be active as a beer judge around the region. I anticipate big things for this small brewery.

Leah Dienes of Apocalypse Brew Works. *Rick Evans photo.*

GREAT FLOOD BREWING

One of Louisville's newest breweries, Great Flood Brewing, opened in the spring of 2014 and was more or less sold out of beer by day three. The three young owners—Matt Fuller, Zach Barnes and Vince Cain—regrouped and returned with a vengeance with their collaboration brew, Kentucky Common, and have since added a bright tank and are looking to expand brewing capacity.

The site's name is a nod to a 1937 natural disaster that submerged the city, and murals along one wall recount this flood. The spacious taproom faces busy Bardstown Road, with leather couches and chairs poised for people-watching at the front of the place. Along both walls are tall bar tables with stools that can seat plenty of people, and there is a standing bar in the middle of the place designed to encourage socialization.

The Great Flood guys came out of the gate with beers that promise great things ahead. The APA was a unique, hoppy experience that almost defies description, while the Hoppy Irish was an interesting take on a red ale. The Brown Ale was among the early favorites, however, becoming one of the first to sell out.

Vince Cain of Great Flood Brewing pulls a pint of Rye IPA. *Jeff Mackey photo.*

Not that they were complaining about the crowds or the sellout. "We're tickled to death," Cain told me the day after in between brewing new batches. Once again, expect big things.

THE FUTURE

As of this writing, several more breweries are in the planning stages. Donum Dei was setting up shop not far from New Albanian's original location in New Albany. Danville, Kentucky–based Beer Engine was working furiously to open a brewery in Schnitzelburg. Red Yeti Brewing has opened its doors in Jeffersonville and hopes to start brewing in 2014. Bannerman Brewing was ramping up to open in Clifton, not far from Apocalypse. And there were plenty of others. Heck, there are even a few brewery chains that beer lovers can check out in Gordon Biersch and BJ's Restaurant and Brewhouse.

For the first time since the late 1800s, brewing is actually growing in Louisville—by leaps and bounds, no less. Numbers that came out of the Craft Brewers Conference in April 2014 show that craft beer sales nationally rose by 18 percent in 2013; overall beer sales actually fell by 2 percent. In addition, the increase in production in 2013 over 2012 was 2.3 million barrels. The number of craft breweries in the United States is at an all-time high—and by a wide margin—at more than 2,600, with more than 400 opening in 2013. But this may be the most important number to watch: more than 1,700 craft breweries are currently in the process or planning stages of opening. Louisville is part of it all.

In fact, it literally has been since before Prohibition that Louisville had so many breweries operating at the same time. The production is nowhere near where it was in the mid-1930s, but it is clear that brewing in the River City is on a steep rise. Prohibition may have won a battle, but the sympathies that drove it continue to lose the war.

"Prohibition was some sort of big moral crusade which was misguided and underwritten by a bunch of high-ranking capitalists because they wanted their workers to be sober so they would work harder and make more money for them," Baylor said. "We forget this whole connection…Then you get to the point where only fifty breweries are left [in the country], then beer is undervalued again. Any time something is undervalued, there is a chance someone will catch on."

The nation has. Louisville certainly has. Its palates are insatiable now when it comes to beer, even in the midst of what is an even bigger bourbon and whiskey boom. Asked why he thinks beer has traditionally been so important in our culture, Baylor replied, "I think beer is important primarily because it's an intoxicant; if we lie about that, we're deluding ourselves. Beer makes you feel good if you use it right."

Sitting in his New Albanian pizza restaurant one day in early 2014, he also said, "It's also important because of what we're doing now. You're having a beer." And we were simply sitting and enjoying a conversation. Which is what it all goes back to—beer helps bring us together. Louisville is embracing that again, and it's showing. People are talking about beer on social media, on blogs, at work and at home. There are beer-themed bars like Sergio's World Beers and Holy Grale. We have the Louisville Beer Store, which is devoted exclusively to craft and import beers. And the home (and local commercial) brewers are served well by Paul Young's My Old Kentucky Homebrew, located just blocks from the former site of Phoenix Brewery.

Louisville even has a website dedicated to covering the beer scene (LouisvilleBeer.com). That site was founded by John Wurth and features a number of beer writers as well as a popular podcast. It also serves as the spearhead and main sponsor of Louisville Craft Beer Week, which happens each fall. "There's a whole lot more to beer than the light-colored lagers we all grew up with," Wurth said. "LouisvilleBeer.com has hopefully helped open the door to tastier beer for a lot of people. I want people to be excited to try new beers, and steering away from mass-marketed yellow fizzy water."

In addition, the Kentucky Guild of Brewers recently appointed its first executive director. John King, a brewing enthusiast and contributor to LouisvilleBeer.com, is charged with helping to create a unified vision for the breweries in Louisville and across the state. One advantage that today's Louisville brewing scene may have over the booming late 1800s is that there is no push to create a monopoly like the Central Consumers Company. "People think [Bluegrass Brewing Company] is competing against Against the Grain," King told me shortly after his appointment. "The breweries are working together. It's a good ol' boy system where, if they run short on malt, they get malt from another brewery."

It's true. When Great Flood was ramping up brewing in anticipation of opening, Leah Dienes and David Pierce were there to help. Bluegrass Brewing Company in St. Matthews collaborated on that Kentucky Common to help Great Flood with volume. With established breweries helping fledgling

breweries that way instead of fearing competition, the brewing scene can only grow and prosper.

King is working toward building relationships with Kentucky's governor, as well as the mayors in Louisville and Lexington. When Louisville mayor Greg Fischer in late 2013 declared a Mayor's Bourbon and Food Work Group, with the goal of maximizing the city's bourbon and dining scene as a tourism tool, King was one of many who felt that local breweries got shafted. There were dozens of people from the distilling, wine, culinary and even coffee sectors, but not one brewery representative. As a result of the backlash, the mayor's office is now looking at ways to promote local beer.

Yes, Kentucky is bourbon country, and bourbon will always be king. But Louisville, once upon a time, was one of the top brewing cities in the nation. With the rise of craft beer's popularity, Louisville is poised to rise to prominence again. Sure, it will likely never have another brewery the size of Falls City, Fehr's or Oertel's. But creativity in brewing is blossoming in Louisville, poised for more growth and recognition. King said that he is also working with the state's tourism bureau to get the breweries added to the bureau's website.

For many, Louisville (and nearby Lexington) already is a craft beer destination. With the growth on the horizon, the potential is almost boundless. "I see us following in the trends," King said. "I think our beer community will constantly change and adapt as the diversity of a craft beer drinker expands. Eventually, I think we will flatline a bit brewery wise in the state, but it won't happen for a bit. On the flip side, we will keep seeing the demand for craft on the rise."

His vision goes beyond Louisville's boundaries, however. "Personally, I would rather see more breweries in the state than more breweries in Louisville," King told me during an interview I conducted for InsiderLouisville.com. "East of Louisville in Owensboro and Paducah are untapped resources. We are growing in Lexington and even farther east. I'd rather Kentucky as a whole have more craft beer available than Louisville in general. The Louisville craft beer scene has grown tremendously in the past five years…I want the state to grow as well."

It most surely will. Craft beer in bourbon country remains undeterred, especially with the cooperative breweries and King doing his best to unite the state and bring brewing back to prominence. I like bourbon, too. But it wasn't bourbon that my dad and Pappaw drank from colorful cans and bottles. It was beer that captured my heart, whether it was Miller High Life

or even the much-maligned Billy Beer. Their love of beer led to mine, and my love of beer grew into a love of craft beer. Heck, I like pretty much any beer. There's just something about beer. It's a magical thing.

In fact, now that I've finished writing this book, I think I'll have one. And I'm going to have one that was brewed in Louisville. Because I can. Cheers.

BIBLIOGRAPHY

BOOKS

Casseday, Ben. *The History of Lousiville: From Its Earliest Settlements 'Til the Year 1852.* Louisville, KY: Hulland Brother, 1852.

Cole, Mr., N.N. Hill Jr., M.L. Bevis, A.R. Wildman and Walter Buell. *History of the Ohio Falls Cities and Their Counties.* Cleveland, OH: L.A. Williams & Company, 1882.

Guetig, Peter R., and Conrad D. Selle. *Louisville Breweries: A History of the Brewing Industry in Louisville, Kentucky.* New Albany, IN: Mark Skaggs Press, 1997.

Hall, Wade. *Hell-Bent for Music: The Life of Peewee King.* Lexington: University Press of Kentucky, 1996.

———. *The Kentucky Anthology: Two Hundred Years of Writing in the Bluegrass State.* Lexington: University Press of Kentucky, 2005.

Johnson, E. Polk. *A History of Kentucky and Kentuckians.* New York: Lewis Publishing Company, 1912.

Kleber, John E. *The Encyclopedia of Louisville.* Lexington: University Press of Kentucky, 2001.

Peake, Michael A. *Indiana's German Sons: 32nd Volunteer Infantry.* Indianapolis, IN: NCSA Literature, 1999.

Prohibiting Intoxicating Beverages: Hearings Before the Subcommittee of the Committee on the Judiciary United States Senate. Washington, D.C.: Government Printing Office, 1919.

Refrigerating World. Vol. 35. New York: Food Trade Publishing Company, 1908.

Smith, Zachariah Frederick. *The History of Kentucky: From Its Earliest Discovery and Settlement to the Current Date.* Louisville, KY: Courier-Journal Job Printing Company, 1892.

Publications

Eisenbeis, Joseph Jacob. *Recollections of Louisville, Kentucky, 1890–1930 (Primarily East-Central Area).* ReoCities.com.

Kentucky Digital Library. "Falls City Brewing Company Records, 1905–1990." kdl.kyvl.org.

One Hundred Years of Brewing: A Complete History of the Progress Made in the Art, Science and History in Brewing in the World, Particularly in the Last Century. Supplement to *Western Brewer.* Chicago, IL: H.S. Rich & Company, 1901.

Articles

Boyd, Terry. "Rising Sea of Microbrewery Foam Is Not Yet Floating All Boats." *Business First*, April 16, 2007.

Courier-Journal. "Among the Beer Kegs." July 4, 1868.

———. "Because of Bock Beer." March 18, 1894.

———. "Beer Garden Waiters." April 29, 1888.

———. "Beer Goes Up: Blow to Hit the Free Lunch." January 3, 1917.

———. "Black Masks." March 8, 1889.

———. "Bock Beer." April 4, 1903.

———. "Bock Beer on Tap in Louisville Today." March 19, 1910.

———. "Bock Beer Will Go on Tap Here To-Day." March 21, 1914.

———. "A Boiler Bursts." February 3, 1885.

———. "Boiler Explosion." August 17, 1883.

———. "Brawl at a Picnic." September 14, 1897.

———. "Brewing Ends at Midnight." November 20, 1918.

———. "A Cask Explodes." August 18, 1889.

———. "Consumption of Beer." September 13, 1887.

———. "Drinkers of Stale Beer." September 17, 1890.

———. "Firm Changes." May 4, 1891.

———. "Freedom's Tribute." July 5, 1889.

———. "The German Festival Yesterday for the Benefit of the Protestant Orphan Asylum." June 13, 1871.

———. "Germans Make Merry at Phoenix Hill." August 27, 1912.

———. "The Jim Jams." November 6, 1881.

———. "The Liederkranz Fest." August 27, 1881

———. "Louisville Beer Barons." March 6, 1893.

———. "Matters of Common Talk." July 27, 1894.

———. "Max Benz's Foolish Deeds." July 6, 1892.

———. "May Prove Fatal." March 17, 1889.

———. "Obituaries." March 16, 1891.

———. "Old Bachelor's Picnic." July 16, 1875.

———. "Ran with Beer." June 18, 1895.

———. "Studies in a Beer Garden." August 22, 1875.

———. "Sunday in Lincoln Garden." June 23, 1883.

———. "Throngs in Parks." April 23, 1900.

———. "Where Beer Is Free." January 11, 1891.

Daily News. "Drink Up: Breweries Are Disappearing but Billy Beer Sales Inch Up." June 8, 1978.

Griffiths, Brooke. "Cumberland Brews Restaurant on Tap for Highlands." *Business First,* August 21, 2000.

Kentucky New Era. "Beer Is Not High in Sales." May 4, 1978.

Louisville Daily Courier. "The Louisville Riots." August 8, 1855.

Riegler, Susan. "Good Food and Brew on Tap." *Courier-Journal,* November 14, 1992.

Robrahn, Steve. "Kentucky Beer Making Return." Associated Press. March 17, 1993.

ABOUT THE AUTHOR

K evin Gibson is a Louisville, Kentucky–based freelance writer who writes about everything from food to music, beer, bourbon and professional football. He loves bacon, loathes cucumbers and once interviewed Yoko Ono (pissed her off a little, too). He published his first novel, *The Liberation of Crystal Hill* (Bearhead Publishing), in 2011; he also is on the verge of self-publishing a memoir about his ongoing battle with Crohn's disease and is about to begin writing his next book. He co-hosts a weekly local radio show called *Flies on the Wall* on Crescent Hill Radio with his pal Butch Bays, and he also plays bass in a local band. Not surprisingly, he doesn't sleep much. But when he isn't running around town chasing stories or poised at his trusty laptop writing, you can often find him at one of the local breweries, being thankful for the life he lives. That, or on his couch with his trusty sidekick Darby. Check out his beer blog (502Brews.com) or his website (KevinGibsonWriter. com) to find out more about his books and why he does what he does. Or feel free to call him names on Twitter (@kgramone).

Visit us at
www.historypress.net

This title is also available as an e-book